IMAGES
of America

HATCH VALLEY

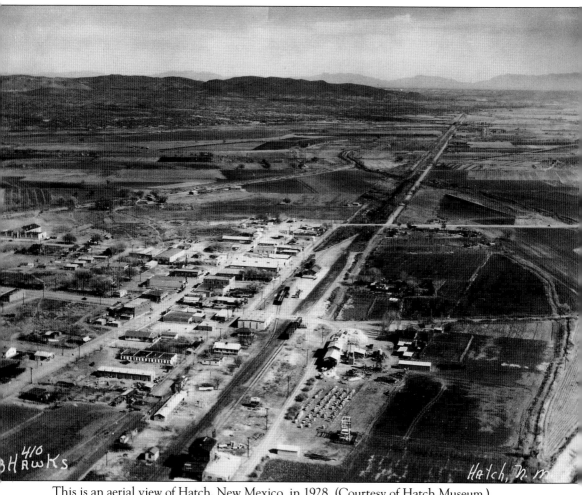

This is an aerial view of Hatch, New Mexico, in 1928. (Courtesy of Hatch Museum.)

ON THE COVER: Bobby Franzoy, who graciously shared this photograph, has spent hours and hours collecting photographs of the Franzoy family (originally spelled Franzoi) to document their history in the Hatch Valley. The cover photograph shows Hatch Valley farmer Tessie Franzoy and a farmhand standing in a field of cotton. Tessie, an immigrant from a region of Austria that is now part of northern Italy, spoke little English when she arrived in the Hatch Valley for her arranged marriage with Alex Franzoy. As the saying goes, the rest is history.

IMAGES
of America

HATCH VALLEY

Cindy Carpenter and Sherry Fletcher

ARCADIA
PUBLISHING

Published by Arcadia Publishing
Charleston, South Carolina

Printed in the United States of America

Library of Congress Control Number: 20104959591

For all general information, please contact Arcadia Publishing:
Telephone 843-853-2070
Fax 843-853-0044
E-mail sales@arcadiapublishing.com
For customer service and orders:
Toll-Free 1-888-313-2665

Visit us on the Internet at www.arcadiapublishing.com

*Dedicated to Jay, Lee, Cordell, Colten, Grace,
Evie, Imogene, Jamie, Kim, Sherry, Yvonne, Beau,
Amanda, Jake, Racheal, Jess, and Cindy Lou*

—Love, Cindy

To Baxter, John, Jessica, Eve, and Maxine

—Love, Sherry

CONTENTS

FOREWORD

My family is very rooted in Hatch Valley, where God has made us stewards of his land for five generations. I have been very blessed to have been raised in the Hatch Valley. It is a beautiful valley, and I cannot imagine living anywhere else. When you are farmers, you are completely dependent on God, and it teaches you that He is your provider. We in the Hatch Valley have been blessed by God, and all that surrounds us in this beautiful valley belongs to Him.

The people that came to the Hatch Valley did not have a sense of entitlement. They were hard workers and believed what the Bible teaches us in 2 Thessalonians 3:10, that "If anyone will not work neither shall he eat." Through hard work, this valley has prospered. This book is an opportunity to share how it all started and how the valley has grown. The book will serve as a reminder to the generations to come that faith in God and hard work is rewarding. We have truly been blessed in the Hatch Valley.

—Racheal Lack Carpenter

ACKNOWLEDGMENTS

We could not have done this book without the support and valued assistance of David Vineyard, Bobby Franzoi (Franzoy), Lisa Franzoy Neal and the staff at the Hatch Library, Mary Frances Whitlock and the Hatch Museum, Louise Benvie, Sherry Russell, Nick Carson, Rory Carson, Fred and Betty Riggs, Dorothy and Lonnie Gillis, Mary Gillis, Dr. Laurence S. Creider and NMSU Library Archives and Special Collections, Racheal and Jake Carpenter, Joette Mays, Carole Bouchard of the Rincon Water Consumers Co-Op, Susan Downs of the Caballo Soil and Water Conservation District, Mary Jo Fahl of the Sierra County Soil and Water Conservation District, Michelle Franzoy Ochoa, Ann Welborn, Joe Paul, and Rosie Lack. We would also like to thank Stacia Bannerman, acquisitions editor at Arcadia Publishing, for her support and encouragement.

INTRODUCTION

Before the designation of the area as Hatch Valley, territorial newspapers documented the history of this particular section of southwestern New Mexico as the Rincon Valley. In the December 13, 1923, edition of the *Rio Grande Farmer*, the US Reclamation Service designated the Rincon Valley as the "irrigable land north of the Leasburg diversion dam and extending up the river to the head of the local irrigation system, the Percha diversion dam." At the suggestion of local historians, the communities as far north as Garfield and as far south as Rincon have been designated as the Hatch Valley for the purposes of this historical perspective.

The town of Rincon grew up by the railroad. If the railroad had not seen the location as a favorable junction in their line, Rincon would not have existed. Early territorial newspapers carried an article known as the "Rincon Locals," reporting on one of the "liveliest towns" around. The railroad was a blessing as well as a curse. In 1883, the *Rio Grande Republican* wrote on November 17 about "an old man, whose name we could not learn, [that] was seriously and perhaps fatally injured by a locomotive. He was picking up the little lumps of coal that were scattered along the track and while in a stooping position, the engine struck him in the head, injuring him very severely, and it is doubtful even if he will recover." As early as 1884, the complaint was being made that the town of Rincon needed more lodging houses because not even half of the travelers could be accommodated with beds. The town was flourishing and fortunes were being made. Not everyone who came to the area was pleased with the climate or the people. The *Rio Grande Republican* reported on February 16, 1884, that the "week of wind, rain and all kinds of weather; and that by the by, makes people generally feel mean and indifferent."

On September 30, 1910, the *Rio Grande Republican* claimed that "only the farmers know how to farm. There are thousands who would like to quit the towns and cities and immigrate to the country, and possess themselves of broad fertile fields, and to make two blades of this, that, or the other of grass grow where one or none grew before, but this proposition presents, that it takes from two to twenty years to learn how to farm, and within such a period bankruptcy might occur several times over. . . . He [the farmer] is the bulwark of the nation and the salt of the earth."

This attitude, however, was not stopping the influx of settlers into the southwest. With increased settlement along the Rio Grande, more water was diverted from the river by private and community ditches. Inadequate precipitation and inequitable water usage had farmers up and down the Rio Grande as far south as Mexico, whose farmers also relied on the river for water, crying "foul." The water from the Rio Grande could be unpredictable. As one unidentified individual had been quoted as saying, the Rio Grande was "too thin to plow and too thick to drink." Just as quickly, the torrential rains of the monsoon season could swell the Rio Grande past its banks, creating floods that wiped out residences, farms, and crops. The government recognized that dependable irrigation and more dependable water storage facilities would be needed to sustain agriculture. On June 17, 1902, Congress passed the Reclamation Act, requiring water users (farmers) to repay the construction costs of any future projects from which they would eventually benefit. The

next month, Congress established the US Reclamation Service to reclaim the arid lands of the Southwest through irrigation, to create more homes for Americans on family farms. To meet that goal in southwestern New Mexico, the secretary of the interior authorized the Rio Grande Project on December 2, 1905. As part of the Rio Grande Project, Engle Dam and the resulting reservoir named Hall Lake were begun to address the water issue. Throughout the dam's construction, territorial newspapers would refer to the dam as either Engle Dam or Elephant Butte Dam. The name of the resulting reservoir was also disputed, with some referring to the waters as Hall Lake and others preferring the name of Elephant Butte Lake. History would record the final chapter in the name saga as Elephant Butte Dam and Elephant Butte Lake. The Engle Dam would allow water from the Rio Grande to be impounded during the wet seasons and then the stored waters could be diverted to the farmers during the dry seasons. It was also believed that the dam could act as a flood control measure to protect farmers of the valley. Construction of Engle Dam was authorized by Congress on February 25, 1905.

In 1911, the *Rio Grande Republican* of April 14 announced that alfalfa was the principal crop in the Rincon Valley. The farmers, not wanting to chance the fickleness of the Rio Grande River, installed six new pumping plants. Although they believed the river would give them plenty of water for their crops, "they know what pumping plants will do and are not taking chances." Although not completed until 1916, Elephant Dam started impounding water in 1915. Communities up and down the Rincon Valley celebrated the completion of the dam.

In 1917 and 1918, work on construction of distribution laterals and drainage systems in the Rincon Valley were completed as part of the continuing work of the Rio Grande Project. Old community ditches were reconstructed and extended from 1918 to 1929, with new laterals formed to help complete the irrigation distribution and drainage systems in the area. The Rio Grande Project also consisted of several other diversion dams that were built during pertinent phases of the project.

Despite the building of Elephant Dam and the massive irrigation and drainage system work, floods devastated the Hatch and Rincon Valleys especially hard during 1921. To the credit of the resiliency of residents, the areas continued to grow and prosper. According to the December 13, 1923, edition of the *Rio Grande Farmer*, the town of Rincon had a Harvey House, general merchandise stores, a bakery, a garage, schools, and churches. The town of Hatch, "located on the Deming and Silver City branch of the Santa Fe, six miles west of the junction with the main line at Rincon, and at the intersection of the state highway, running north and south through the state, with the railroad," was the shipping and supply point for the Rincon Valley. The village of Hatch had a 75-barrel flourmill operated by the Southwestern Milling and Elevator Company, along with a wholesale distributing station for the Continental Oil Company. Heavy commodities that included flour, agricultural implements, machinery, hardware, and lumber were being handled in "car loan lots" and distributed wholesale. The US Reclamation Service operated a yard, storehouses, and superintendent's office in Hatch. Hatch also had several general merchandise stores, a bakery, a garage, schools, and churches. The river continued to sustain the agriculture and the railroad had created the commerce. Hatch Valley farmers were prosperous.

Many historians give credit to Lafayette Clapp and the railroad for the existence of the town of Hatch. Clapp had moved his family to the area in the winter of 1891. Clapp partnered with a Mr. Price to mill corn and wheat as part of a mercantile business. Clapp and Price also worked as agents for the Atchison, Topeka & Santa Fe Railroad. Early Hatch, located on the Deming and Silver City branch of the Santa Fe Railroad, six miles west of the junction with the main line at Rincon, had been called Hatch Station. A man with a vision, Clapp bought real estate in the area that he surveyed and parceled them into lots he called the Clapp Subdivision in 1911.

Below the Hatch Railroad Station was the town of Rodey, formerly called Colorado. Going north would take one to the small communities of Salem and Garfield. None of these three towns would ever prosper to the extent of Rincon and Hatch. The first building in the Hatch area became a saloon. In 1914, the newly chartered Bank of Hatch acquired that now abandoned saloon building and prosperity was in the wind. In the 1920s, the New Mexico State Highway Department built

a road that linked Hatch with Las Cruces to the south and Albuquerque to the north, ensuring the prosperity of the town. The village of Hatch was incorporated in 1927, and Lafayette Clapp was named the first mayor. He would serve in that position from 1927 to 1930

In 1922, the Bowman Bank & Trust Company of Las Cruces consolidated with the Bank of Hatch. The new facility would operate out of Las Cruces under the name of Mesilla Valley Bank. The Bank of Hatch had been unable to regroup after the devastating flood of 1921. Pat Campbell, the cashier at the Bank of Hatch, worked in the new Mesilla Valley Bank as cashier.

As the world suffered through the Great Depression, Rincon also suffered. The Lake Valley silver mines closed; the railroad terminated services due to the decline of railroad services; the Harvey House, which was synonymous with railroad travel, was torn down; and railroad workers were laid off, leading to the row houses in Rincon being torn down, sold, or moved. Rincon remained a shipping point for agricultural products, but on a much smaller scale. As Hatch continued to grow, Rincon faded into the background.

As part of President Roosevelt's New Deal to help give relief to families suffering from the Great Depression, men between the ages of 18 through 23, and later from 17 through 28, were sent to manual labor jobs that worked on conservation and development of natural resources in lands that were owned by federal, state, and local governments. The Civil Conservation Corps (CCC) was used during the Great Depression to plant trees along the irrigation canals and construct dikes in order to help protect areas from flooding.

In 1935, the CCC workers would be credited with saving the town of Hatch by building a temporary dyke of sand bags along the north side of the railroad tracks to help minimize flood damage. In 1940, the CCC workers of Hatch built the largest CCC-built structure in the Southwest, the Spring Canyon Dam. The Spring Canyon Dam was about a mile and a half from the city of Hatch and was to be the last important construction project built by the Soil Conservation Service in their Hatch flood protection program.

The Spring Canyon dam was not designed to impound water, but rather to provide a flood control structure. Not one single lost time accident had been reported, despite the fact that 3,700 pounds of dynamite and heavy machinery had been used on the dam. Dr. W. Smith, the CCC camp superintendent, acted as foreman, and the work was done by CCC enrollees with the occasional assistance of a few skilled operators and carpenters.

In 1938, a fire in the Black Range Forest blazed out of control and workers from the CCC camps in Hatch were called upon to relieve the weary firefighters on the fire line. In 1941, Dr. J.P. White, the Hatch CCC physician, taught a Red Cross first-aid course in the recreation hall of the CCC camp for two evenings. Thirty women from Hatch and Rincon, along with four men and boys, attended the course.

During the Great Depression, Mexican immigrants were deported or pressured to leave the United States as part of what was called the Mexican Repatriation. Therefore, when World War II came around and men left the valley to join the war effort, there were fewer immigrant workers available when the labor demand returned. Hatch Valley cotton farmers were worried they might not be able to get their crops in. As World War II raged on, there was a battle brewing at the Hatch school board meeting in July 1942. Several school districts around New Mexico had been considering proposals for a split school year that would allow students to be dismissed from school between October and November to help pick cotton. The school board flatly rejected the proposal, but left the door open in case there was a "real emergency." The farmers sounded off in the *Las Cruces Sun News* on July 9, 1942, saying, "The farmers say the emergency is already is here—unless they succeed in getting imported labor out of Mexico; the farmers—some of them at least—insist that this year's cotton crop cannot be picked without the aid of school boys and girls." Eventually, the Army would allow German and Italian prisoners of war to be housed at the abandoned CCC camp in Hatch and to work in the fields as laborers for the farmers. The Bracero Program, named for the Spanish word *bracero* (manual laborer), was also implemented in August 1942 between the United States and Mexico, allowing the importation of temporary contract laborers from Mexico to the United States. The Bracero Program officially ended in 1964.

It is impossible to write about Hatch Valley without mentioning red or green chile. Confusion begins with how to spell the word, as it is written as both "chili" and "chile." According to experts, "chile" is the actual plant, and it is "chili" when used as a spice. However, not everybody adheres to this, and the word chili is often used when referring to the plant. When did chile actually come to the Hatch Valley? Oral history says that Joseph Franzoy was the first commercial grower/producer of chile in the valley. It was being grown by residents and used in food long before he came to the valley in the early 1900s. Joseph Franzoy's great-granddaughters, Lisa and Michelle, tell the story about Joseph sampling the chile cooked by local residents. He was said to have come home yelling to his wife, Celestina, to "hurry quick; I've been poisoned." It is easy to imagine his mouth burning, his eyes watering, and his mouth "on fire." His pain must have been short lived, and he apparently decided he liked the taste. By 1929, chile was in hot pursuit of King Cotton in the Hatch Valley because farmers could make more money on an acre of chile than they could on an acre of cotton.

Hatch was prospering. Residents could buy an automobile locally in downtown Hatch and have their choice of either a Dodge, Plymouth, Ford, or Chevrolet. Farmers could shop the Meyers General Mercantile store. Farmall and John Deere tractors could be bought locally, and general hardware stores had everything a farmer needed. O.C. Browning & Son sold plumbing and electrical fixtures, as well as appliances. Robert Porter & Sons had building materials, lumber, Zenith Radios, furniture, American kitchens, and general electric appliances. In contrast, as the village of Hatch grew, the small community of Rincon faded.

Chile became the official vegetable of the state of New Mexico (although it is technically a fruit till harvested). It is said that the official state question is "Red or Green?" New Mexico State University, in nearby Las Cruces, New Mexico, was credited with over 130 years of work on developing most of the varieties of chile grown in the Hatch Valley today.

By 1954, 31 percent of Dona Ana County's 51,940-acre cotton crop (Hatch Valley is in Dona Ana County) was harvested with mechanical pickers. Cotton, alfalfa, pecans, and other crops continue to be raised in the valley today. Some farmers use mechanical chile pickers, while others continue to pick it by hand. Chile drying is done commercially and frozen or dried chile is shipped to places all over the world.

The first annual Hatch Valley Chile Festival was held in 1972. The festival continues each year. During the late summer to early fall of the year, the smell of roasting chile is enjoyed by visitors and residents alike.

One

EARLY TIMES
IN THE RINCON VALLEY

Rincon Station, the junction where the Atchison, Topeka & Santa Fe Railroad branched off for Deming, Silver City, and Lake Valley, had another name: Thorn Post Office. According to an article published on February 17, 1883, in the *Rio Grande Republican,* the "railroad has given the town one name and the government the other." As the national postal service already delivered to a town called Rincon in northern New Mexico, their solution was to name the town Thorn Post Office, after the short-lived Fort Thorn located just a few miles up the river. When the northern town changed its name, Dr. Hugo B. Kohl, Rincon's second postmaster, changed the town's postal name to Rincon. Spanish for "corner," Rincon is surrounded by mountains on three sides.

Rincon owed its existence and reputation to the railroad. As a railroad town, it stood to reason that business would be more robust when the trains came into town. The same article mentioned above complained that "business [was] being done at night and the people [were] taking long naps during the day. This has had a deterius [*sic*] effect on the morals of a portion of the community and has made Rincon a favorite resort for rustlers and desperadoes of the most notorious stripe." Not wanting to scare off new residents, the article went on to say that it was also a safe town and that a "peaceably disposed person can stay there as safely as in a large city, and never be molested, unless he seeks a quarrel on his own accord."

When the Atchison, Topeka, & Santa Fe Railroad completed its Rincon-Deming line in 1881, a second transcontinental route from Kansas City to Southern California had been established. In the process of laying the rail line, another community, named Hatch's Station, was established. The name would later be changed to Hatch. By 1915, Rincon Valley, of which the Hatch Valley was a part, was said to have 21,500 acres of irrigable land. Other communities of the Rincon Valley included Garfield, Salem, and Rodey.

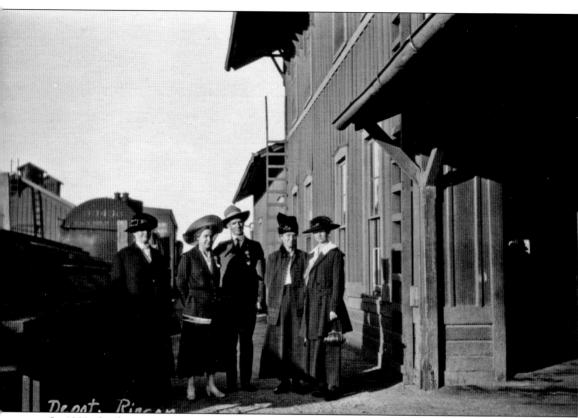

In 1883, the depot at Rincon was under the management of Otto Arnold. He was assisted in the office by J.P. Booth and an unnamed telegraph operator. Passengers and freight came in and out of the station. Nearby was the Rio Grande Hotel, owned and operated by Mr. McClintock. New hotels were springing up all around town. Claims were that the railroad had attracted tramps to the area. The *Rio Grande Republican* of February 16, 1884, reported that a L. Hanson said, "If the miserable tramp who stole the last pair of drawers and shirt that he [Hanson] had for a change, would consider that fact, and bring them back, no questions would be asked." By 1911, Rincon had a population of 500 and was said to have churches, a school, an electric light plant, a newspaper, a printing plant, and city water. (Courtesy of New Mexico State University Library, Archives and Special Collections.)

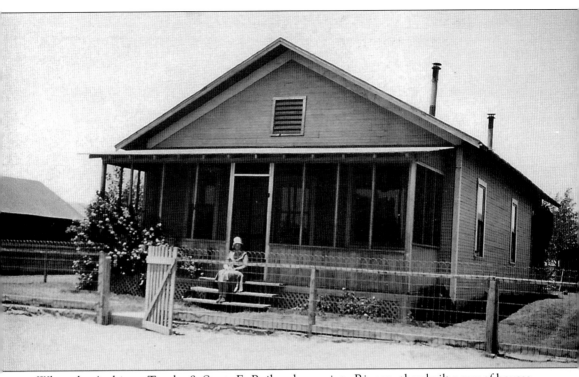

When the Atchison, Topeka & Santa Fe Railroad came into Rincon, they built a row of houses across from the Rincon station to house railroad workers. According to local Rincon resident David Vineyard, the home shown above was built in 1887 and housed the railroad stationmaster and his family. Eventually, the railroad would sell, haul off, or tear down all of the homes except for the one shown above. New owner Mable Hawthorn, a local teacher, is shown sitting on the front porch in this 1926 photograph. It was not until 1930 that homes in Rincon were powered by electricity. The Mesilla Valley Electric Company wired electricity to the railroad first and then to local residences shortly after that. Hawthorn lived in this home until her death. Today, the home is owned and occupied by David Vineyard and his wife, Diana. (Courtesy of David Vineyard.)

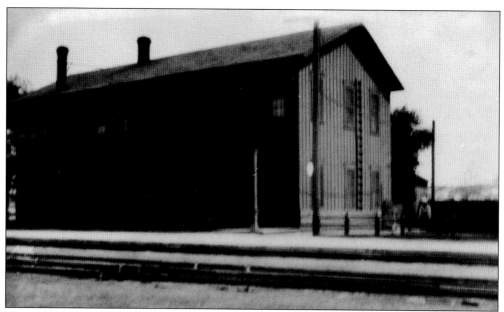

Harvey Houses were a chain of eating house-hotel establishments built along railroads in the western United States as early as 1878. Fred Harvey, owner of the Harvey House franchise, believed in providing quality food and services. Waitresses at the Harvey House were known as the "Harvey Girls." This Harvey House was located in Rincon. (Courtesy of the Hatch Museum.)

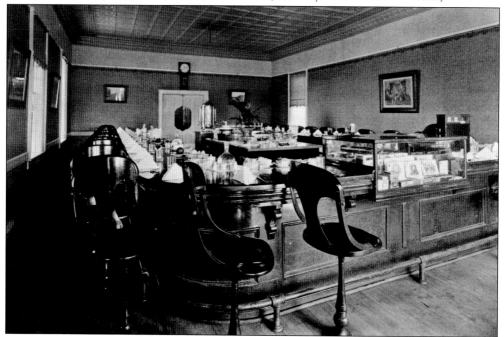

The railroad provided the building for the Harvey House, and Fred Harvey would provide the equipment and the personnel. These establishments were noted for their elegance. Railroad workers and visitors alike were treated with excellent service and a friendly smile. This photograph shows the inside of the Harvey House located in Rincon. (Courtesy of New Mexico State University Library, Archives and Special Collections.)

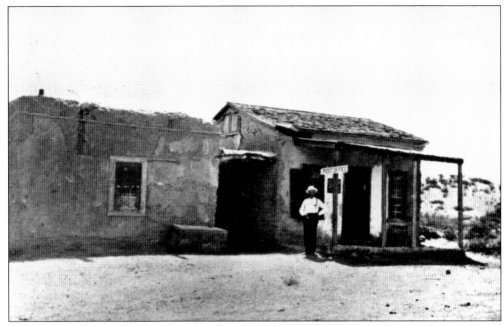

The *Rio Grande Republican* reported on March 20 1886, that J.R. Board Jr., a mail agent on the route between Rincon and Deming, was sentenced to two-and-a-half years in the penitentiary for stealing a registered letter containing $130. This rare photograph shows the early Rincon post office. (Courtesy of New Mexico State University Library, Archives and Special Collections.)

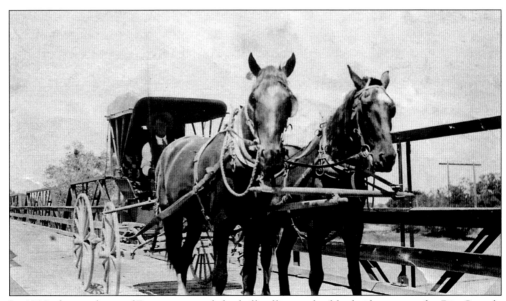

In 1909, the residents of Rincon started the ball rolling to build a bridge across the Rio Grande between Rincon and Hatch. According to territorial law (New Mexico did not become a state until 1912), a petition had to be signed by 100 taxpayers in order for the county commissioners to issue bonds for the building of a bridge. (Courtesy of Hatch Museum.)

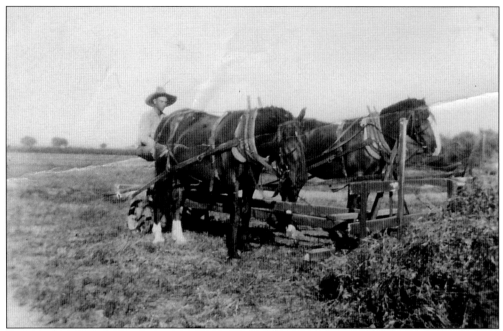

Hay was baled in the early morning because the hay was damp and there was less chance of knocking off the leaves, which provided vital nutrients. This photograph shows a Rincon Valley farmer pushing a wooden rack built on the front of the horse-driven baler into piles. Hay wagons would pick the hay up. (Courtesy of Bobby Franzoy.)

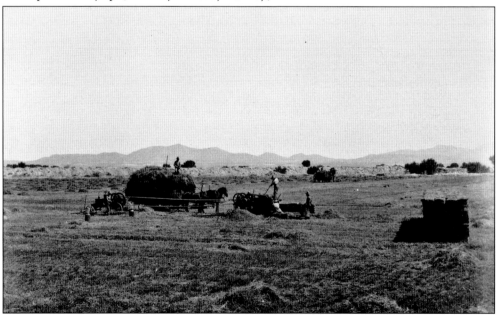

The stationary baler, or hay press, was invented in the 1850s but was not widely used until the 1870s. A steam engine ran the belt of this early baler. The wagon would deliver the alfalfa to the baler, the man would punch the alfalfa down into the baler, and the baler would push the finished bale out the side. (Courtesy of New Mexico State University Library, Archives & Special Collections.)

Nancy (left) and Mary Benvie stand before an adobe house in the town of Rodey, New Mexico. In the June 30, 1911, edition of the *Rio Grande Republican*, it was said that Rodey was then 40 years old and formerly known as Colorado. The post office was established in 1906, and the town was renamed in honor of a congressman with the last name Rodey. (Courtesy of Louise Benvie.)

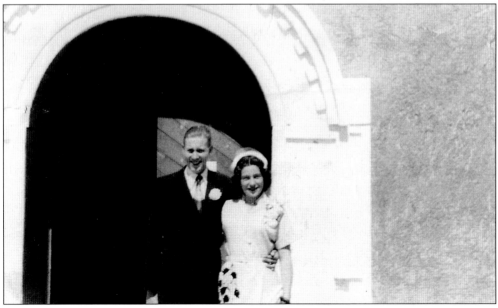

Louise Franzoy and George Crighton Benvie were married on April 11, 1953, in this church, located in Salem, New Mexico. This small church continues to serve a faithful congregation in the community of Salem. Oral history says that Salem was named by a group of settlers from Salem, Massachusetts, who settled in the area. (Courtesy of Louise Benvie.)

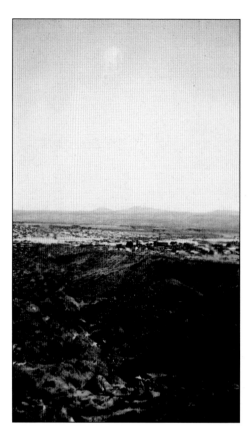

This photograph shows Rincon from Indian Canyon in the summer of 1932. In 1934, the *Rio Grande Farmer* carried an article titled "Hatch and Rincon News" in each edition they published. Pertinent information carried in the September 6, 1934, edition noted, "Mrs. Virginia Cunningham is recovering from a tonsilar operation." (Courtesy of New Mexico State University Library, Archives and Special Collections.)

The St. James Episcopal Church purchased and remodeled the old Rincon schoolhouse with donations from the community. The *Rio Grande Farmer* reported in its April 5, 1934, edition that the first service would be Easter evening. Friar Willis would be conducting the service, and Rev. Hunter Lewis would be attending. (Courtesy of Hatch Museum.)

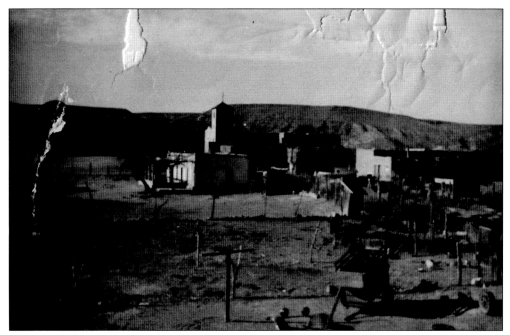

This rare photograph of Rodey, New Mexico, shows the extensive use of adobe as a common building material in the area. In the distance, the steeple of the St. Francis de Sales Catholic Church can be seen. Rodey had a post office from 1904 to 1927 but never achieved the economic status of Hatch. (Courtesy of Louise Benvie.)

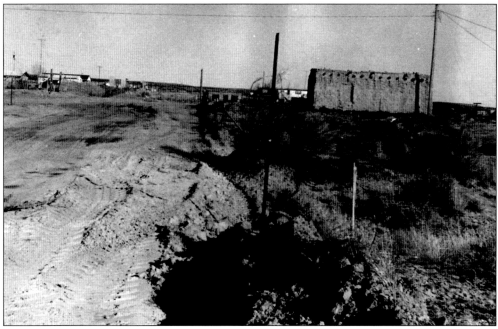

Adobe, or sun-dried brick, one of the oldest building materials known to man, was frequently used in the construction of buildings in the Rincon Valley. Early adobe bricks consisted of sand, sometimes gravel, clay, water, and a straw or grass mixture. Unfortunately, early adobe was unstable, shrinking and swelling with water exposure. (Courtesy of Hatch Library.)

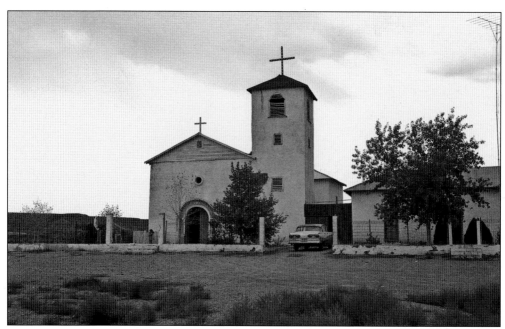

The beautiful St. Francis de Sales Catholic church in Rodey is now a registered historic place. When the population of Hatch increased and Rodey's did not, a new Catholic church was built in Hatch under the title of Our Lord of Mercy. Once the Hatch church was complete, the seat of the parish was transferred there and the church in Rodey was closed. Oral history says that two former priests lie buried under the altar of the Rodey church. The last priest to say Mass in Rodey was Father Klumbis. When the building was privately sold, the bell tower and the two-foot-thick adobe walls were replastered. Both photographs show the St. Francis de Sales Catholic church from different angles. (Both, courtesy of New Mexico State University Library, Archives and Special Collections.)

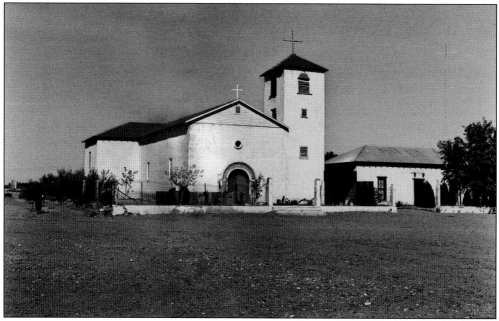

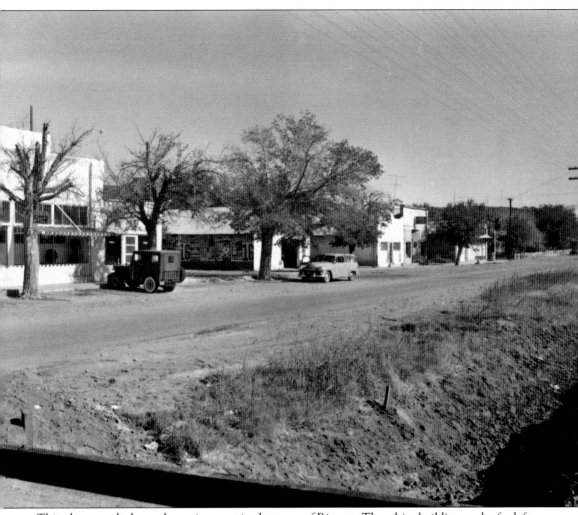

This photograph shows the main street in the town of Rincon. The white building to the far left is the Brazeal Mercantile store. Signs in the window advertise vegetables as well as women's and men's clothing. In 1934, J.E. Brazeal of the Brazeal Mercantile Company announced he would be putting in a new general merchandise store in Hatch. For the location of the new store in Hatch, Brazeal had bought the building where Virgil Carter had the Ford Agency. Brazeal announced that the new store would carry staple and "fancy" groceries, men's and women's clothing, and dry goods. Brazeal was also well known in Las Cruces. In 1939, Brazeal, along with another man, purchased a 27-acre tract in Las Cruces that they were developing into a subdivision they would call Mountain View. Homes within the subdivision were restricted to a $2,500 value or more. They promised there would be no delay in installing gas, sewer, and water. (Courtesy of New Mexico State University Library, Archives & Special Collections.)

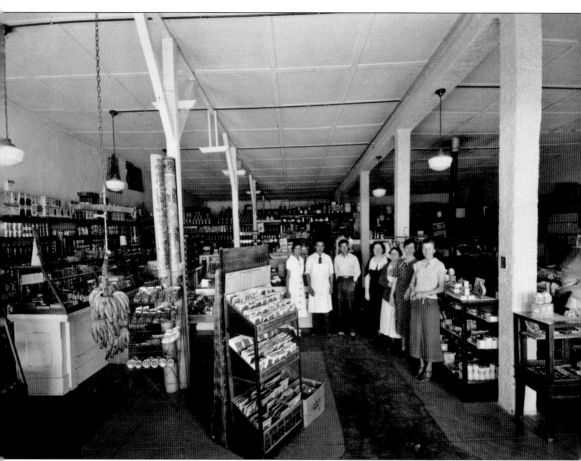

Employees who worked in the Brazeal Mercantile store in Rincon in 1936 are, from left to right, Patricia Samaniego, Dan Sanchez, Jesus Garcia, Mrs. Brazeal, Mrs. Banghart, Mrs. Faught, and Ruth Dorbandt Ware. In 1941, the Kerr Jar Company, working with the Women's Extension Club and Farm Security, held canning contests in the Brazeal Mercantile store in Hatch. Exhibits to the Women's Extension Club were separate from exhibits to the Farm Security. Exhibits to the Women's Extension Club required two jars each of fruit, vegetables, and meat. The Farm Security contest only required one jar of each in their exhibit. Contestants were not allowed to enter their jars in both exhibits. The three best exhibits would then compete with contestants from Las Cruces, New Mexico. That contest was held on October 21, 1941, in the Myers Company Store in Las Cruces. (Courtesy of New Mexico State University Library, Archives & Special Collections.)

Two

FLOODS, FLOODS, AND MORE FLOODS

In an article of the *Rio Grande Republic* on February 19, 1920, L.M. Lawson, manager of the Reclamation Service of the Rio Grande Project, talked about 111 farmers and their families from Arizona who had come to settle in to the valleys of New Mexico during the past 12 months. He wrote, "Most of them drove here in their high-priced automobiles and put up at hotels where the ordinary man would have difficulty in financing a breakfast. They simply wanted to find an irrigated country where they and their families might raise good crops and at the same time enjoy a climate in which they might live with comfort."

Then on August 18, 1921, the headlines of the *Rio Grande Republic* stated the tragic news, "Cloudburst Destroys Town of Hatch—All Store Buildings and Dwellings Completely Demolished." According to the publication, Hatch businesses and residences were two-to-seven feet under water. Hatch Valley crops were destroyed. The paper warned that flooding due to the rise of the Rio Grande could reach El Paso and Juarez later that night.

Elephant Butte Dam, completed in 1916, was built as part of the Rio Grande Project to give farmers a regulated water supply for crops and to also provide some protection against flooding. Despite the dam and the canal and drainage work done through the Rio Grande Project, the flooding was devastating in 1921. Hatch Valley residents focused the blame on the government for the flood of 1921, claiming that the Reclamation Service had not provided adequate culverts in the area to address the problem of flooding. Another major flood struck the area again in 1935.

Photographs from the archives and special collections at New Mexico State University show the devastation of the flooding that attracted the attention of all the local newspapers of the time. Unfortunately, 1935 would not be the last devastating flood to hit Hatch, New Mexico.

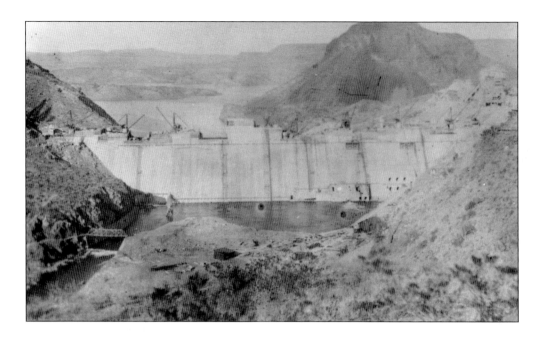

Elephant Butte Dam, originally called Engle Dam, was authorized by a congressional act on February 25, 1905, and was formally dedicated in 1916. One of the first projects of the Rio Grande Project, its main focus would be to aid in irrigation and flood control for farmers. It was built at a site named Elephant Butte, about 42 miles from the village of Hatch. When the government realized that resources from farmers and public land sales could not pay for the dam and other projects planned as part of the Rio Grande Project, Congress had to change the way Reclamation operated. The modification of the law required the secretary of the interior to deal only with irrigation districts instead of individual farmers. (Both, courtesy of Sherry Fletcher.)

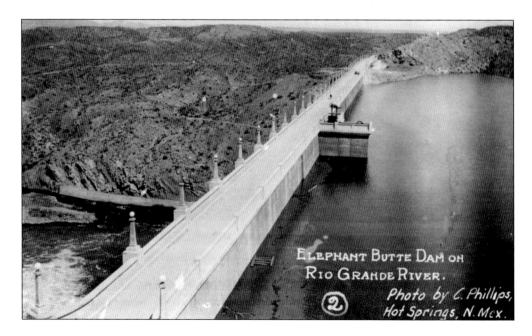

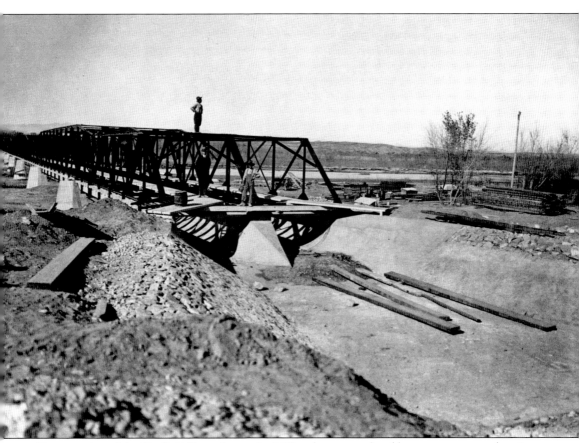

Construction of the Garfield Flume began in 1917 and was completed by government workers in February 1918. This photograph depicts the construction of the flume during 1917. The flume provided the connecting link between both the Garfield Canal and the Hatch Canal. The Rincon canal, a 27.1-mile-long irrigation canal, would cross over the Rio Grande in the Garfield Flume and then under the river at Hatch and Rincon to provide irrigation water to farmers of the area. Unfortunately, the flume was inoperable during the growing seasons of 1918 because there was a contractor delay on the work being done on the Garfield Canal. When the Rio Grande Project was complete, there would be 152 miles of main canal with two flumes that were 54 miles in length. (Courtesy of New Mexico State University Library, Archives and Special Collections.)

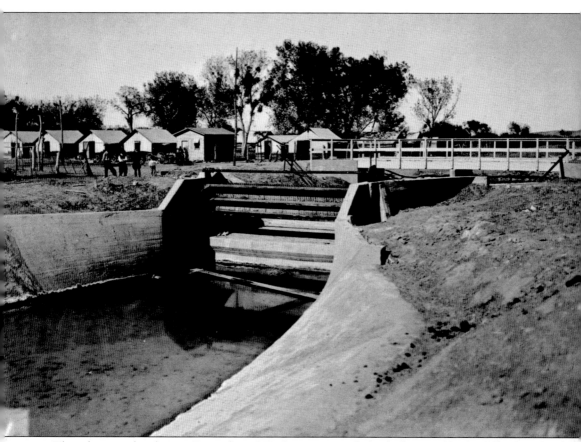

This photograph taken in December 1917, shows a typical check drop and highway bridge on the Garfield Canal. The project was over 90 percent complete on June 30, 1918. At the end of the fiscal year of 1918, it was noted that the irrigable acreage for the Rio Grande Project when the project was complete would be 155,000. The acreage cropped under irrigation for the season of 1917 was estimated at 63,626. The value of the irrigated crops in the season of 1917 was $3,598,424.00, and the value of irrigated crops per acre cropped was $56.50. The water rental charges accrued to the end of the 1918 fiscal year was $420,703.63, and the amounted collected at the end of 1918 was $375,612.07. (Courtesy of New Mexico State University Library, Archives and Special Collections.)

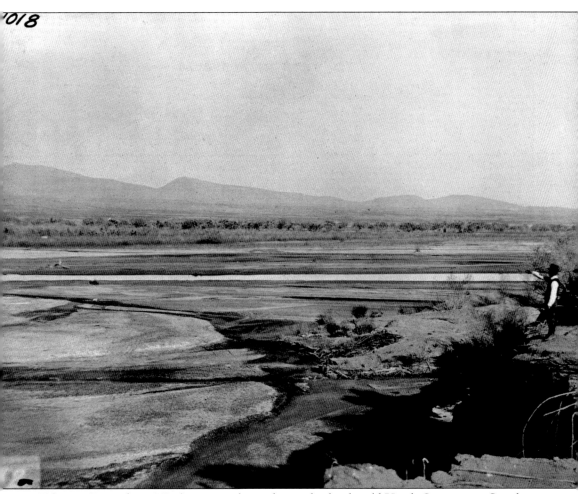

Taken in December 1917, this image shows the intake for the old Hatch Community Canal, a small ditch located throughout the Hatch Valley. The Hatch Community Canal was deeded over to the government in December 1917, allowing the community canal to be part of the main canal system for the entire Rincon Valley. The diversion system for the Rio Grande Project consisted of 128 miles of main canal. Water for irrigating 1,700 acres in the Rincon Valley was diverted at Percha Dam, which was 30 miles below the Elephant Butte reservoir. Before the existence of the Rio Grande Project, the areas of the valley were irrigated by constructing canals, such as the Hatch Community Canal, at strategic points along the Rio Grande. These canals could not withstand the periodic flooding and served only as temporary solutions for a growing problem. (Courtesy of New Mexico State University Library, Archives and Special Collections.)

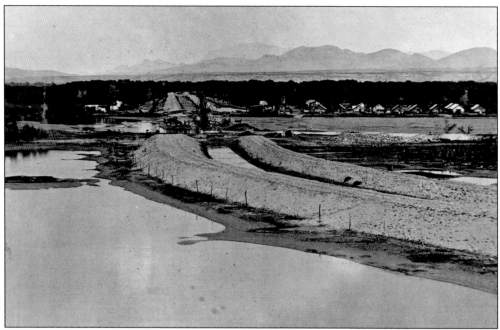

This photograph shows the site of the Hatch Siphon with the Garfield canal in the background. The embankment for the Hatch canal on the flood plain of the Rio Grande can be seen in the foreground. All of these projects were completed to improve irrigation efforts to Hatch Valley farmers. (Courtesy of New Mexico State University Library, Archives and Special Collections.)

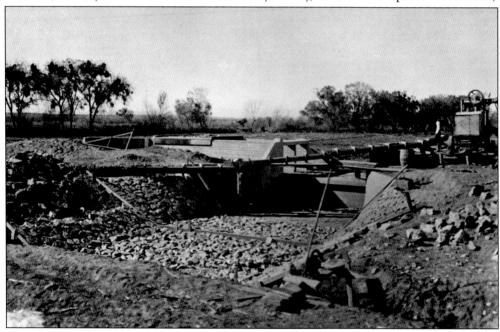

This photograph, taken December 1917, shows the combined check drop and turnout for the Garfield canal. Drops span the canal in order to drop the water level from a higher elevation to a lower elevation. They are made of concrete to prevent erosion. (Courtesy of New Mexico State University Library, Archives and Special Collections.)

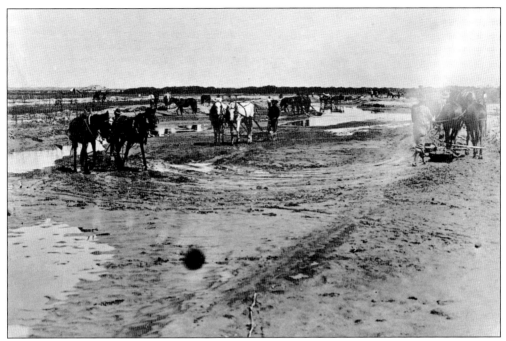

The irrigation plan of the Rio Grande Project was designed to provide storage of the floodwaters of the Rio Grande in a reservoir that could be controlled by Elephant Butte Dam. Irrigation water could then be diverted from the Rio Grande to water the farming lands of the Rincon Valley, of which the Hatch Valley was a part. The Hatch Canal was part of the Rio Grande Project and was completed in March 1919. These images show workers removing silt from the temporary intake of the Hatch Canal in July 1918. (Both, courtesy of New Mexico State University Library, Archives and Special Collections.)

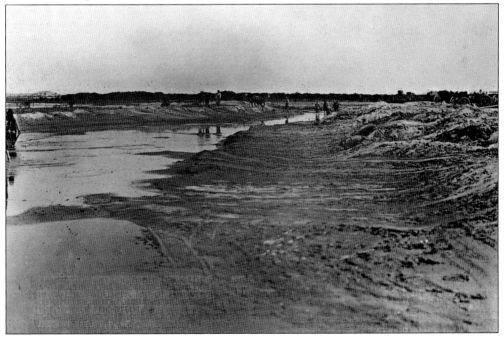

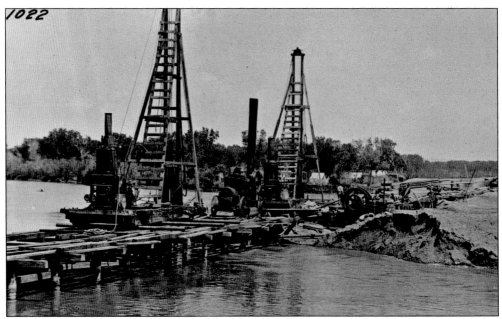

In 1918, it was said that the Elephant Butte Dam, completed in 1916, had successfully provided consistent water for irrigation of the Rincon Valley despite the fact that it was the smallest river flow on record. The farmers received the water necessary for irrigation because of the consistent water supply being held in the Elephant Butte Reservoir. In order to continue to protect farmers from the droughts and low water resources, the Rio Grande Project provided funding for drainage, lateral canals, and a limited amount of main canal and structure work. Both images depict the construction of the Hatch siphon, which was a concrete structure that would provide transportation of irrigation from one side of the Rio Grande to the other. (Both, courtesy of New Mexico State University Library, Archives and Special Collections.)

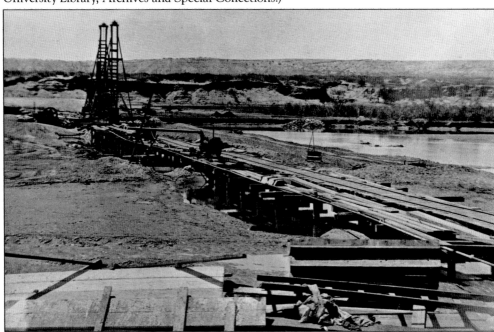

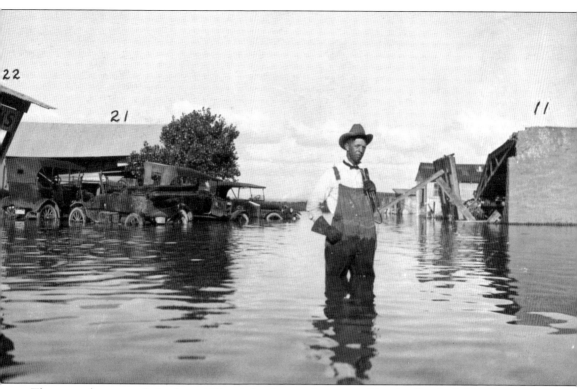

The man above stands in the middle of the devastation created by the flood of 1921. Farms, homes, and businesses were destroyed, and lives were uprooted. This time period is represented by an extensive photograph collection from the New Mexico State University Photo Archives. Unfortunately, cameras and photo printing during 1921 was expensive and not readily available. Vintage photographs of laborers, native New Mexicans, and immigrants were most likely lost during the flooding that occurred over several decades. There are a limited number of photographs of individuals of different race and ethnicity available during this time frame. (Courtesy of New Mexico State University Library, Archives and Special Collections.)

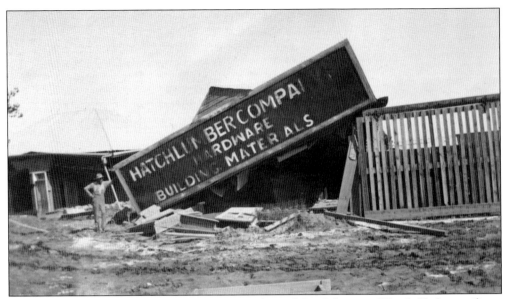

In 1918, R.P. Porter of Las Cruces and R.W. Brownlee and Geo Johnson of Hatch filed a certificate of incorporation of the R.P. Porter Company, a general lumber company. This photograph, taken August 17, 1921, is said to show the lumber company owned by T.C. Holwell and R.W. Brownlee. No further information could be found. (Courtesy of New Mexico State University Library, Archives and Special Collections.)

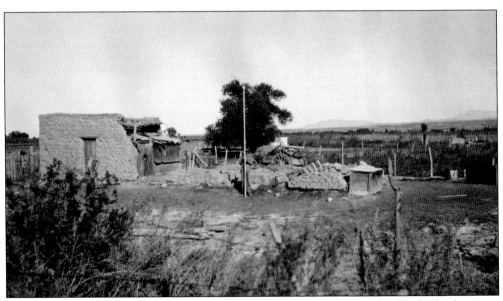

This photograph was taken October 24, 1921, a little over a month after the flood. This barn was made of adobe, a very popular building material at the time. With the right mixture of sand, clay and a little water, adobe could be easily manufactured in the desert climate. Unfortunately, water melts adobe into a heap of mud. (Courtesy of New Mexico State University Library, Archives and Special Collections.)

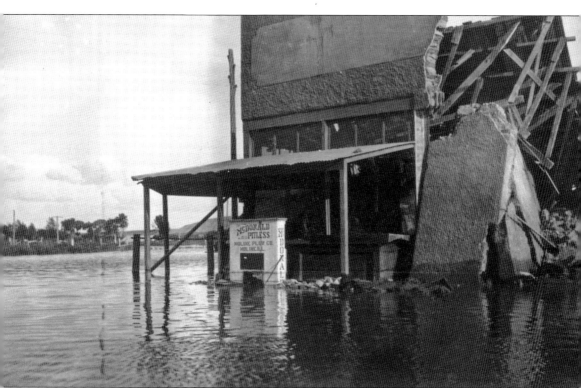

This photograph was taken showing the front of T.C. Hollowell's store in Hatch. The advertisement in the front of the store indicates that the store sold McDonald Pitless Wagon Scales that were manufactured by the Moline Plow Company. The wagon scales came complete with the exception of the seven-plank flooring needed to complete the setup. They advertised steel joists and metal frames. The Moline Plow Company was formed in the 1840s and was a competitor to the early Deere and Company. The company built a tractor called the Moline Universal Tractor between 1916 and 1923. It was said to be small, light, and affordable. It was an early attempt to serve an unmet market. The Moline Plow Company was headquartered in Moline, Illinois, and manufactured plows and other farm implements. (Courtesy of New Mexico State University Library, Archives and Special Collections.)

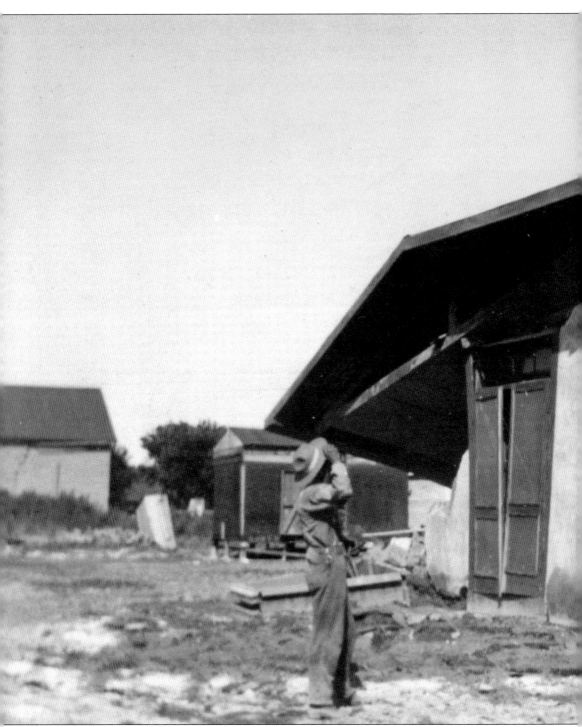

As quoted in the November 30, 1917, issue of the *Rio Grande Republic*, the vice president and cashier of the Bank of Hatch said, "The Hatch Valley extends a hearty invitation to all good, worthy farmers who care to cast their lot with us." He went on to say that the "bank is the big asset to every farming community. It is an institution that the farmers cannot get along without,

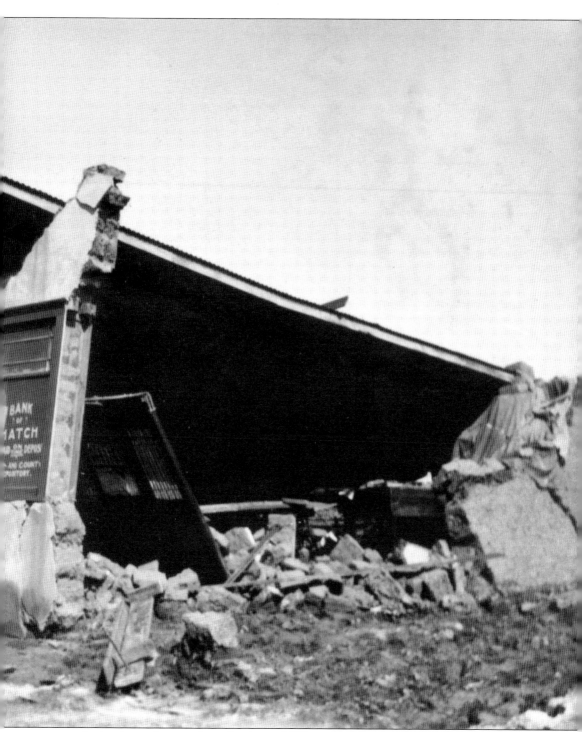

nor can the bank get along without the farmer." When the floodwaters subsided on August 17, 1921, the Bank of Hatch had suffered the same devastation as most of the town. (Courtesy of New Mexico State University Library, Archives and Special Collections.)

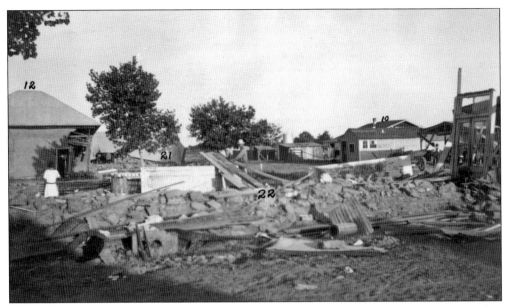

The flooding of 1921 was devastating to local businesses and those who owned them. This photograph shows the salvaging being done days after the floods. In the foreground are the remains of E.L. Stewart's Drug Store. (Courtesy of New Mexico State University Library, Archives and Special Collections.)

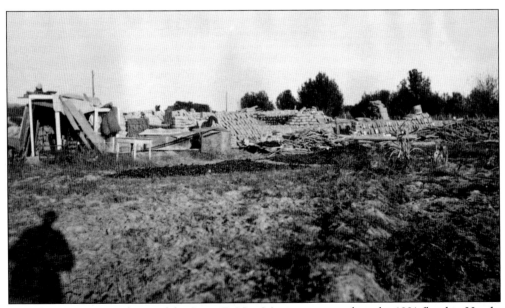

The August 19, 1921, edition of the *Santa Fe New Mexican*, reported on the 1921 flood in Hatch, saying, "the houses were almost all adobe and they crumbled rapidly when the water came down from the foothills and flooded the town . . . only one building was standing-the school house because it had a brick foundation." (Courtesy of New Mexico State University Library, Archives and Special Collections.)

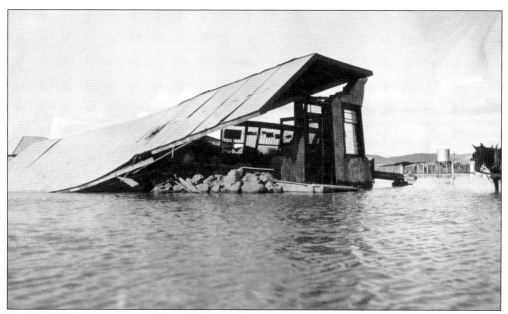

In 1915, J.E. Bonar was president of the Bank of Hatch and Lafayette Clapp was the secretary. The photograph above shows the bank underwater from the 1921 floods. In 1915, the stockholders voted in favor of reducing their capital stock from $30,000 to $25,000. (Courtesy of New Mexico State University Library, Archives and Special Collections.)

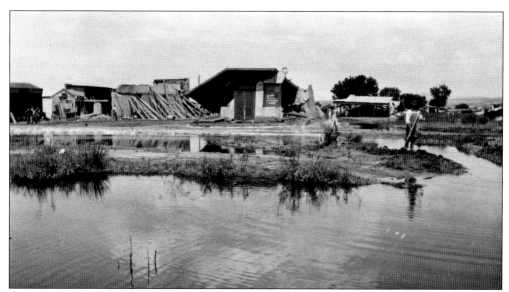

The Bank of Hatch stands prominently in the middle of this photograph. There were other businesses that had stood next to the bank that were left in shambles from the flooding of 1921. The lone man with the shovel is doing what he can to channel the water away from the businesses. (Courtesy of New Mexico State University Library, Archives and Special Collections.)

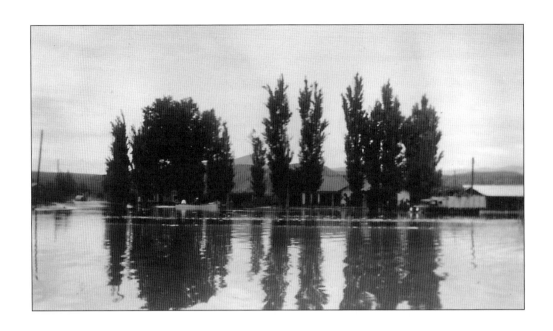

In 1927, Congress passed an act that the comptroller general took to mean that the Elephant Butte Irrigation District would have to bear the charges for flood relief for the 1921 flood that had devastated the Hatch Valley. The *Albuquerque Journal* reported on February 25, 1932, that the "joint resolution relieving the Rio Grande Project from obligation to reimburse the reclamation fund for the Hatch flood items had passed the Senate on Wednesday." The goal was to relieve the Elephant Butte Irrigation District "of the necessity of paying the claims for damage done by the flood in Hatch in 1921." These photographs show the flood of 1935. (Both, courtesy of Hatch Museum.)

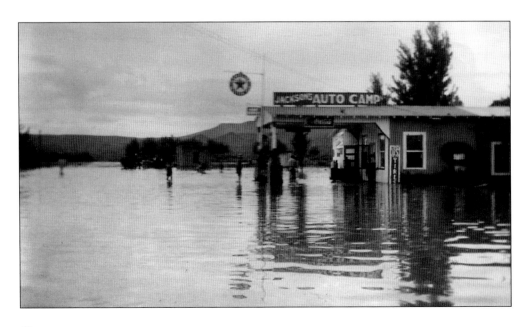

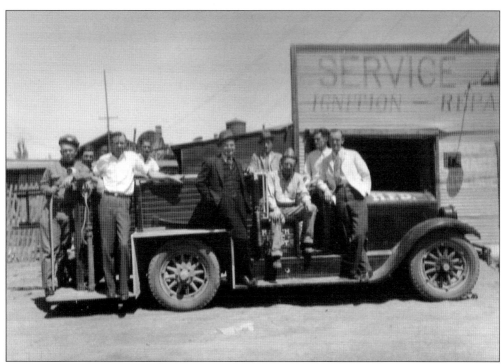

The "H.F.D." painted on the roof of this truck clearly designates that this truck belonged to the Hatch Fire Department. Oral history indicates that the Hatch Fire Department was established prior to 1936. It is said that the original fire department also housed classes for first and second graders of the Hatch School District. A bell summoned early firemen to fires. The picture on the right shows the same service garage pictured above during the 1935 flood. The downpour of rain during that flood was said to have lasted more than two hours. To help with the devastation, Hatch called upon neighbors from the communities of Kingston, Hot Springs, and Elephant Butte. There were no reports of death the day of the flood, but it was said that the loss of livestock was staggering. (Both, courtesy of Hatch Museum.)

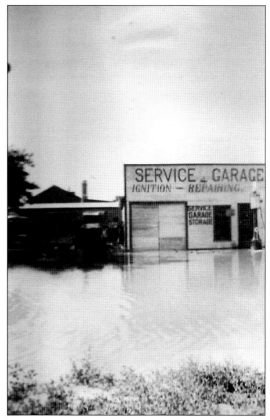

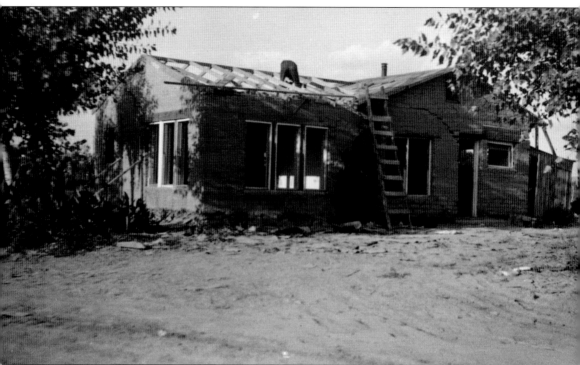

This was just one of many residences that was partly destroyed by flooding from Spring Canyon on September 3, 1935. The owners, like many of residents of Hatch, elected to reconstruct their home and continue to live in their beloved Hatch Valley. In 1936, the Elephant Butte Irrigation District (EBID) constructed Caballo Dam, just 22 miles downstream from Elephant Butte Dam. Smaller diversion dams and canals were also built to help move water to the farmers. The residents felt when the project was completed in 1938 that the Hatch Valley would be safe from future flooding. This however, was not to be the case. The village of Hatch and the surrounding Hatch Valley would see floods in 1988, 2002, and 2006 that would cause significant property damage. The community continued to rebuild each time. (Courtesy of New Mexico State University Library, Archives and Special Collections.)

Spring Canyon Dam, located less than two miles from Hatch, was dedicated in 1940. According to an article ran in the *Deming Headlight* of July 5, 1940, Arthur Starr of Hatch welcomed all to the dedication saying that "the celebration was arranged in appreciation of the work well done by the Soil Conservation Service, Civilian Conservation Corps and the assistance of the father of the Spring Canyon Dam, our great Congressman, John J. Dempsey." F.E. Ferguson, superintendent for the Hatch schools, was the master of ceremonies. He was joined by Representative Dempsey and New Mexico governor John Miles. Hugh M. Milton, president of State College, said "that the most commendable achievement of our contemporaries in the United States has been the great work, which they have done in the conservation of our natural resources." He concluded with, "the most important conservation work in the Southwest is flood control and water storage." Governor Miles thanked Representative Dempsey for his part in making the flood control project possible. This photograph shows Spring Canyon resident Elsie (Vest) Lack. (Courtesy of Joette Mays.)

The Soil Conservation Service began work on a dam across Spring Canyon, two miles south of Hatch, in October 1940. The dam was not designed to be an impounding structure, but was built in conjunction with a watershed conservation program already underway. Past floods had caused significant damage to the Hatch Valley, and flood protection was needed. CCC enrollees from the SCS-CCC Camp 34N at Hatch provided the labor and were supervised by the Soil Conservation Service. With a concrete base 43 feet thick, the dam would be 408 feet long at its crest and 54 feet high in the dam's center. At its capacity, the dam temporarily would hold back 550 acre-feet of water. The water would be released slowly through a permanent, free discharge outlet that was located at the dam's base. It would take about 36 hours to empty the reservoir. This photograph, taken just below the dam in Spring Canyon, shows residents, identified from left to right as Elsie Lack; Joe Lack; Vada Jones; and Vada's son, Scotty. (Courtesy of George Basabilvazo.)

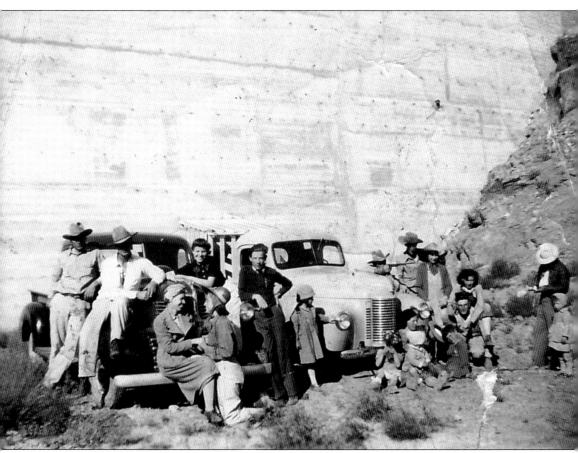

This photograph shows the face of Spring Canyon Dam, located just outside of Hatch. The dam represented the largest concrete structure of its kind built by the Soil Conservation Service in the Southwest. The *Gallup Independent* of June 27, 1940 stated, "These floods formerly emptied with full force into the town damaging buildings, irrigation systems and crops." With flood damage as high as $25,000 in the past, the town had hopes that Spring Canyon Dam would protect the area from flooding. Flooding has historically hit the Hatch Valley through two sources, Spring Canyon and Placitas Arroyo. According to a recent report from the US Army Corps of Engineers, the entire village of Hatch lies within a 100-year floodplain. Annual flood damage today runs as high as $1,100,000. (Courtesy of Bobby Franzoy.)

On May 24, 1939, the *Las Cruces Sun News* reported that the arroyo in Spring Canyon near Hatch needed attention. A plan to complete a program on the watershed in Spring Canyon to included "range control, fencing and water development, and supplementary treatments such as contour furrows and spreader dikes, which will tend to retard the flood waters." This photograph shows the upper part of Spring Canyon watershed. The 7.2-square-mile watershed drains from the south, flowing north into the Rio Grande. According to the *Albuquerque Journal* of February 15, 1940, "As an equally important phase of the flood control plan, Hatch has for the last two years undertaken proper grazing use and conservation treatment on the watershed." (Courtesy of New Mexico State University Library, Archives and Special Collections.)

Three

THE BUILDING
OF HATCH VALLEY

By 1915, the village of Hatch, with a population of 1,000, was a shipping point for the upper part of the valley and the base for supplies for mining camps and cattle ranches. An article in the *Rio Grande Republic* on February 10, 1921, stated that the "Town Of Hatch Is Growing." Work was being done to get the Southwestern Mill & Elevator Company's plant up and running. P.F. Campbell, vice president and cashier of the Bank of Hatch, stated an increase of several thousand dollars to the bank's assets in the last two months. Farmers reported that the 1921 winter wheat acreage was larger than before, and they predicted that the spring wheat acreage would also increase.

Despite the devastating flood of 1921, Hatch was rebuilt. In 1922, a system of draining ditches was installed, and the US Reclamation Service closed a deal to purchase 100,000 pounds of shelled corn from the farmers of Rincon Valley. The alfalfa crop was considered to be a "bumper crop." Plans to increase the dairy industry were discussed. Hatch business men planned a big barbeque, according to the December 14, 1922, edition of the *Rio Grande Republic*, for all the farmers in the valley and "calves and suckling pigs will be roasted and plenty of trimmings to go with them, ample to take care of the large crowd which is expected." The H.K. Truck Line had put in a daily service from Las Cruces to Hot Springs, with Hatch being the midway point and the last railway town on the way north.

Four trains stopped at Hatch daily, connecting the town with the main line of the Santa Fe Railroad at Rincon and with the Southern Pacific at Deming.

Hatch Union High School, completed in 1928, was investing in the future of their youth by providing education in the form of Future Farmers of America and home economics classes. A bright future was in store for this little farming community. Despite more flooding, the Great Depression, and World War II, prosperity was knocking at their door.

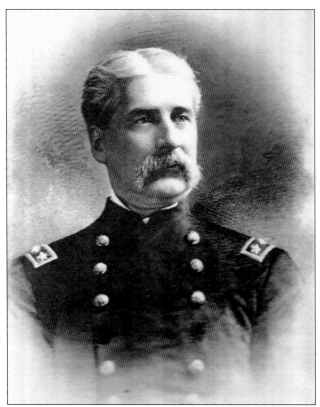

In 1875, a new community sprung up near the abandoned town of Santa Barbara. When the Atchison, Topeka & Santa Fe Railroad laid its line beside this community around 1881, they called the site Hatch's Station. Hatch's Station, later shortened to Hatch, honored the current commander of the US Ninth Calvary and military district of New Mexico, Gen. Edward Hatch. (Courtesy of Hatch Public Library.)

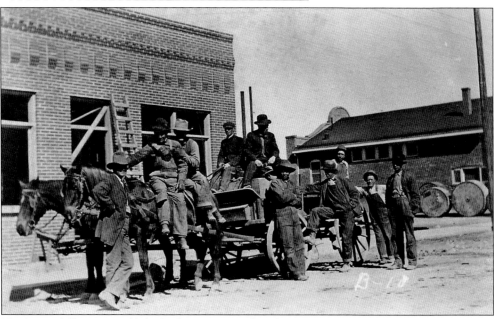

Hatch Post Office was established February 2, 1887, by John G. Huntington, a railroad watchman and express man (person who delivered parcels, letters, etc.). Lafayette Clapp is credited with surveying the town site of Hatch in 1911 and opening a mercantile business and mill. This photograph shows the town's main street in the early years. (Courtesy of Hatch Valley Museum.)

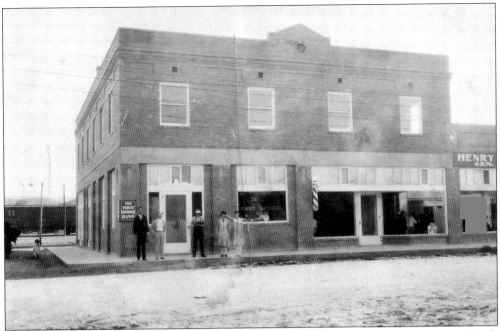

The First National Bank Building was built on the corner of Hall and Price Streets in Hatch in 1926. Oral history indicates that the shorter man beside the man in the suit was R.V. Ware, who is said to have operated the bank from the Hatch Post Office until the building could be completed. (Courtesy of the Hatch Museum.)

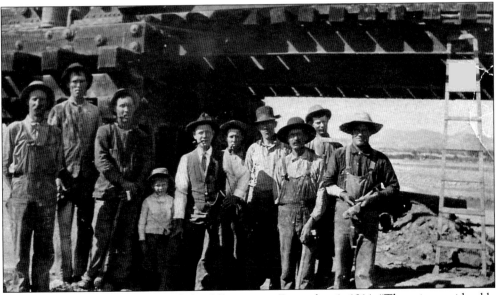

The *Rio Grande Republic* reported the following on December 1, 1914: "There is considerable complaint among the farmers and merchants about the lack of a road crossing near the railroad bridge over the Rio Grande. The railroad people promised to have this crossing put in some time ago, which would shorten the distance to Hatch from the other side of the river about two miles." (Courtesy of Hatch Museum.)

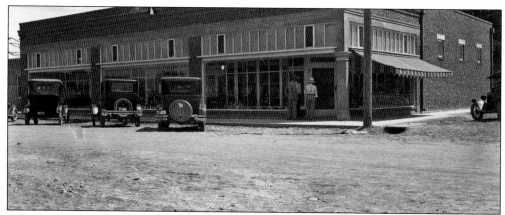

In 1923, the Myers Company Store was advertising house paint no. 437 brown for $3.35 per gallon and barn, bridge, and roof paint no. 461 red for $2.50 per gallon. J.N. Hendricks was the manager of the Hatch store. The company advertised that four gallons would give two good coats on a 16-feet-by-32-feet poultry house. (Courtesy of New Mexico State University Library, Archives & Special Collections.)

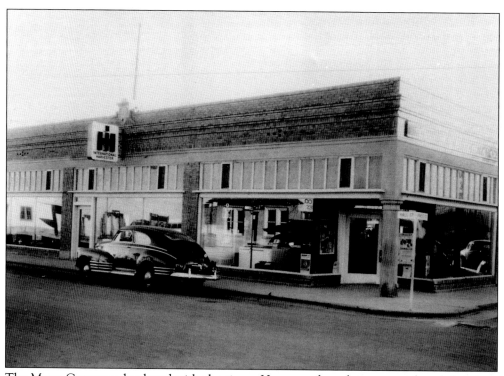

The Myers Company developed with the times. However, they always remembered their best customers, the farmers. During World War II, it was said that the farmers had to deal with the War Production Board. Steel for tanks was in demand, and producing a new tractor was not high on the Army's list of needed equipment. (Courtesy of Chuck Watkins.)

In 1926, several men in Hatch who were Masons decided that the time was right to have their own lodge. They convinced a builder to add a second story to his building, giving the members a meeting room for the new Masonic Lodge, Val Verde No. 62. Together, the founding members shared in the financial expense of renting the room. The picture above shows the building where the second floor was added to accommodate the Masons. When the old grade school building came up for sale in 1939, members of Val Verde Masonic Lodge No. 62 raised $3,500 to purchase the building and remodel it into their new lodge hall. The lodge was granted a charter in 1928. (Both, courtesy of Hatch Museum.)

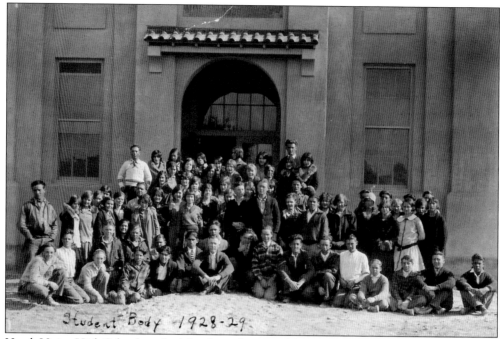

Student Body 1928-29

Hatch Union High School was built by the architectural firm of Trost & Trost and was completed in 1928 for an original cost of $35,000. The firm was based in El Paso, Texas, and was popular throughout the Southwest for building municipal buildings and schools. The firm's chief designer was Henry Charles Trost, and the Hatch high school was designed in the popular architectural style of that time, the Mission Revival Style. The one-story, T-shaped building was 144 feet across by 54 feet deep and faced south. It contained six classrooms, two home economics room, a combination gym and auditorium with a stage, restrooms, and two offices. The picture above shows the student body of the 1928–1929 school year. The picture below shows the back of the school. (Both, courtesy of Hatch Library.)

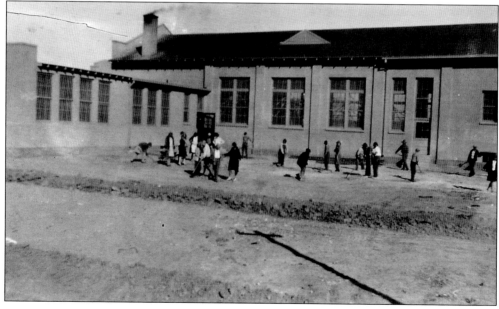

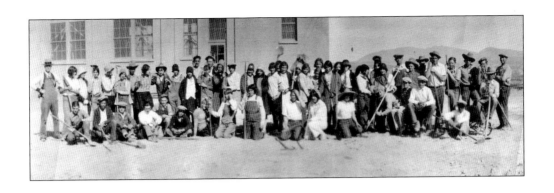

The caption on these photographs was "Day of Cleanup." Both photographs were taken during the 1928–1929 school year. Commencement ceremonies were held May 12, 16, and 17. Reverend Johnson gave the baccalaureate sermon, and Prof. R.G. Breland of New Mexico Agriculture and Mechanic Arts (now known as New Mexico State University) would deliver the commencement address. The graduating class of 1929 consisted of nine seniors and was the first class to have spent a full four years at Hatch High School. The senior class gift to the school was a cement sidewalk that ran from the building to the street. Two years later, the *Gallup Independent* of June 27, 1930, indicated that "Improvements to the ground at Hatch Union High School [were] under way." (Both, courtesy of Hatch Library.)

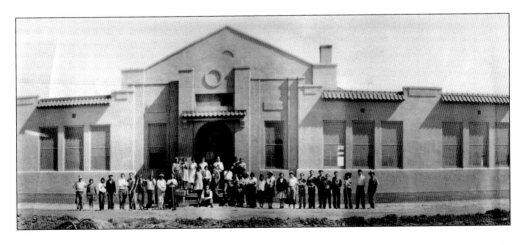

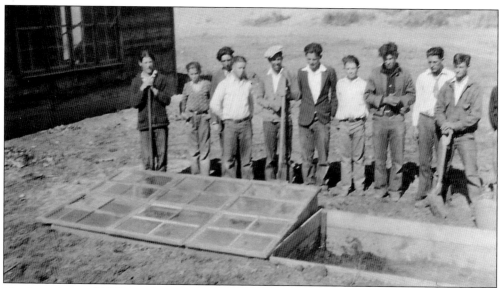

Hatch students of 1928 are shown east of the agriculture shop working on what appears to be bedding plants or seedlings. The glass cover over the bedding plants was raised if the weather was too hot and lowered in the cold to protect the young seedlings. Farming in the Hatch Valley was a way of life for young men in the valley. For those able to further their education, the New Mexico College of Agriculture and Mechanic Arts (later renamed as New Mexico State University) was 42 miles away in Las Cruces. The college was established under the Morrill Act of 1862, or the Land Grant College Act, which was set up to establish institutions in each state that were devoted to educating individuals in practical professions such as agriculture, home economics, and mechanical arts. (Both, courtesy of Hatch Public Library.)

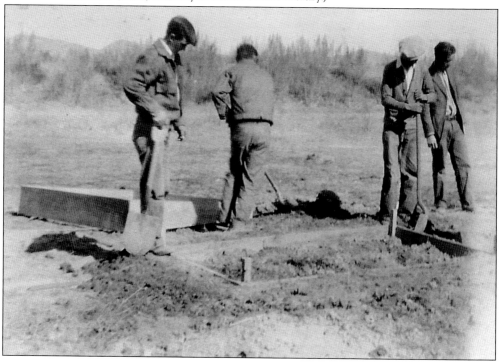

This photograph of the girls' basketball team at Union High School was taken during the 1928–1929 school year. It was not unusual for high schools in 1928 to have a girls' basketball team. The image below shows the 1929 Hatch Union High football team. According to the *Deming Headlight* of September 28, 1928, "Hatch has been developing a football complex and must not be regarded as a set up for the [Deming] Wildcats." The game was to be on Wednesday, October 10. Deming businesses were being encouraged to let their employees off to watch the football games that season. (Both, courtesy of the Hatch Library.)

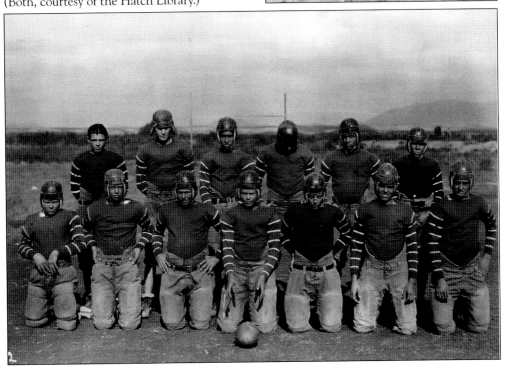

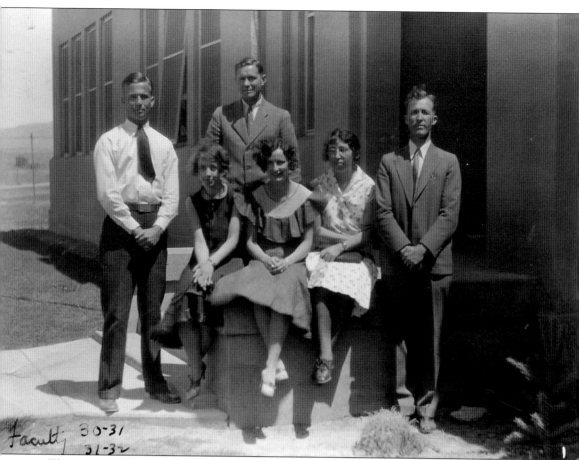

Facult; 30-31
31-32

The most notable feature of the faculty of Union High School (taken sometime between 1930 and 1932) would appear to be the youthfulness of the group. It was a time when men wore suits and ties and women dressed up in their best. The *Gallup Independent and Evening Herald* on May 6, 1931, indicated that a high school principal in McKinley County, another rural area in New Mexico, could make $160 a year, and grade school teachers could make $100 a year. The stock market had crashed in 1929, and Hatch, along with other parts of the United States, was experiencing the Great Depression. In March 1930, there were 3.2 million people unemployed. There was pride and commitment in the eyes of these individuals as they prepared to educate the youth that entered through the doors of Hatch Union High School. There was also the security of being employed during a time when individuals were struggling to make a living. (Courtesy of Hatch Library.)

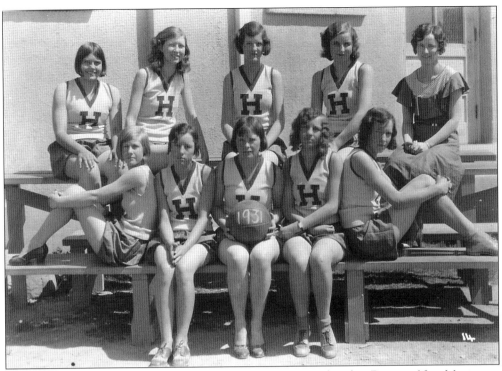

When the Hatch High School girls' basketball team of 1930 played in Deming, New Mexico, at the tournament games in March, there were costs associated with the trip. The Deming girls' basketball team took action, soliciting donations from Deming citizens. The team raised $200 to pay for visiting teams' accommodations and tournament trophies. (Courtesy of Hatch Library)

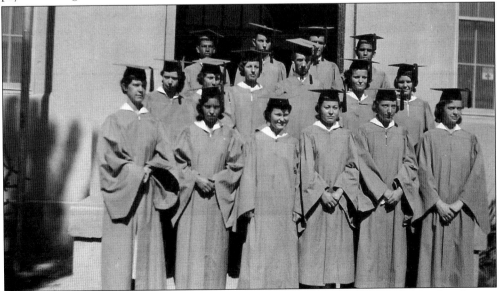

Reverend Cox gave the invocation at the baccalaureate services for the Hatch High School graduation class of 1934 on Sunday, May 13, at 11 o'clock in the high school auditorium. A chorus of high school girls sang the song "I'll Be True." The baccalaureate sermon, titled "Worship," was preached by Friar Willis. This photograph shows the seniors of 1934. (Courtesy of Hatch Library)

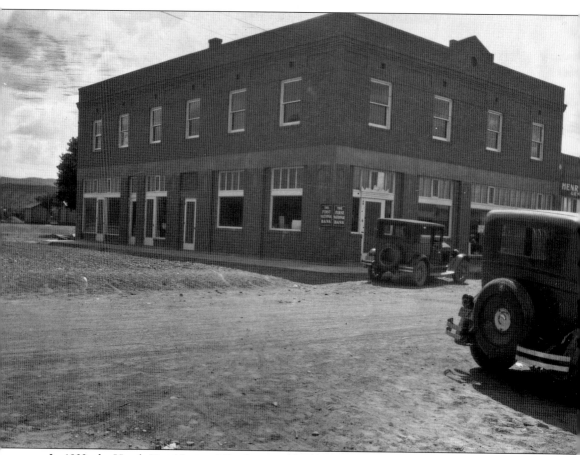

In 1932, the Hatch First National Bank was robbed by G.L. Redding. Redding was identified by bank employee Coke Johnson and three other Hatch residents as the bandit who held up the bank and then rode his black horse into the hills. Good police work located Redding at Frank Burris Jr.'s ranch in Cambray, New Mexico. Redding was milking a cow when officers approached him. Armed with a revolver, the *Deming Headlight* (June 10, 1932) noted that he "offered no resistance when he saw the great odds against him. He refused to discuss the robbery or to make any statement concerning his arrest." Redding had an airplane pilot's license on him and had gotten away with $2,000. As of June 10, 1932, the money had not been found. The *Roswell Daily Record* reported the following on June 9, 1932: "Elsie Jarnigan, waitress, at the Corner Café, Hatch, said she served pie and milk to Redding shortly before the holdup. J.A. Harris, Hatch Mercantile Co., said he sold cookies to Redding." (Courtesy of New Mexico State University Library, Archives and Special Collections.)

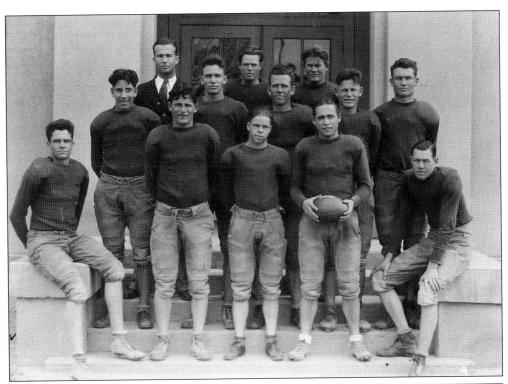

The 1932 football team of Hatch Union High School looked fierce in their uniforms. Note the padding in their shirts. Today, the Hatch High School football team is known as the Hatch Bears. (Courtesy of the Hatch Library.)

Pictured in 1929 at the age of 27 is Frank Brookshire, who was a coach and teacher at Hatch High School at the time of this photograph. Frank was born in Kentucky. His wife, Florence, two years his junior, was born in Illinois and was also a teacher at the high school. According to the 1940 census, Frank was living with his wife in Maxwell, New Mexico, where he continued to teach. (Courtesy of the Hatch Library.)

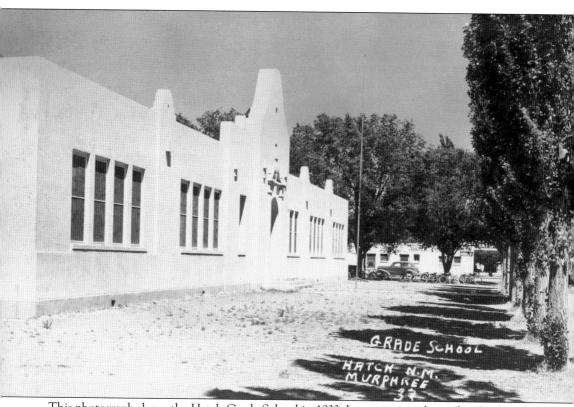

This photograph shows the Hatch Grade School in 1933. Just nine years later, the Hatch Valley Board of Education was faced with the hard facts of World War II. A student who would have been attending grade school in 1933 was now in high school. World War II had farmers fearing a labor shortage during the 1942 cotton picking season. That same year, the Hatch school board rejected what was called a split school year that would have permitted students to be dismissed between October 2 to November 30, the peak of the cotton picking season. The board, along with Superintendent F.E. Ferguson, did agree that an emergency situation might arise and the consideration for student labor could be considered. No actual explanation of what would constitute a "real emergency" was given. Education was valued above all else, and F.E. Ferguson was one of the few superintendents in the area to speak out against using the youth during their school time. (Courtesy of New Mexico State University Library, Archives and Special Collections.)

The Hatch High School basketball team played in the District 4 basketball tournament in March 1931. The team attended the basketball tournament games along with New Mexico towns Hot Springs, Anthony, Las Cruces, Lordsburg, Silver City, Hurley, and Deming. (Courtesy of Hatch Library.)

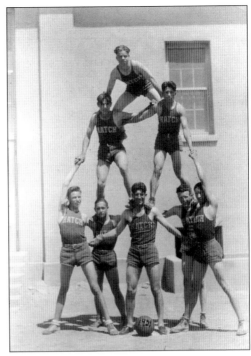

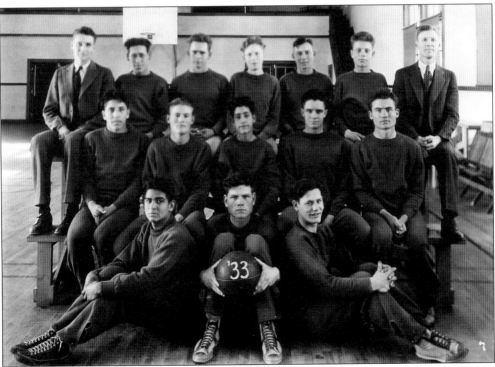

In 1933, the Hatch boys played Deming High School in Hatch. Although Deming beat Hatch (the score was 15 points for Deming and 14 points for Hatch), a *Deming Headlight* article of February 10, 1933, noted that "Slightly off form they [Deming] were unable to ring the basket as regularly as usual and they had to fight until the last second to win." (Courtesy of Hatch Library.)

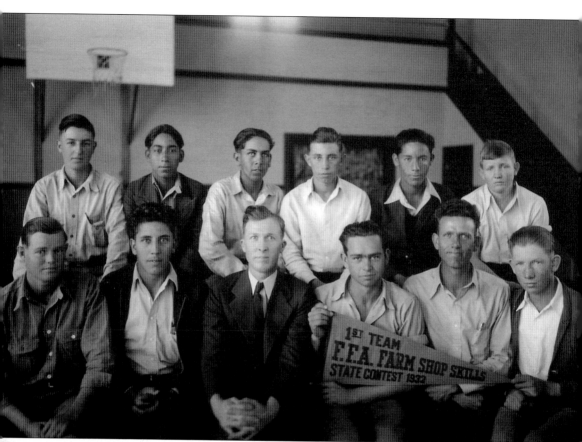

Future Farmers of America (FFA) officially clarified that membership to the FFA was for "boys only" at the 3rd National Convention, held in 1930. (Girls were admitted into the FFA in 1969.) Originally, the FFA was started to serve high school students. Today, students at the middle school level can belong to the FFA. The official colors of the FFA are national blue and corn gold. These colors were adopted at that 3rd National Convention. In 1933, official delegates voted the blue corduroy jacket with the FFA emblem on the back as the FFA's official dress. Pictured are FFA members of 1933 at Hatch Union High School. As can be seen by the banner they held, they placed first in the 1932 state contest in the area of Farm Shop Skills. The man in the middle would have been the teacher that was in charge of the FFA class. Preparing young men for work as farmers was an integral part of the FFA in Hatch, New Mexico. (Courtesy of Hatch Library.)

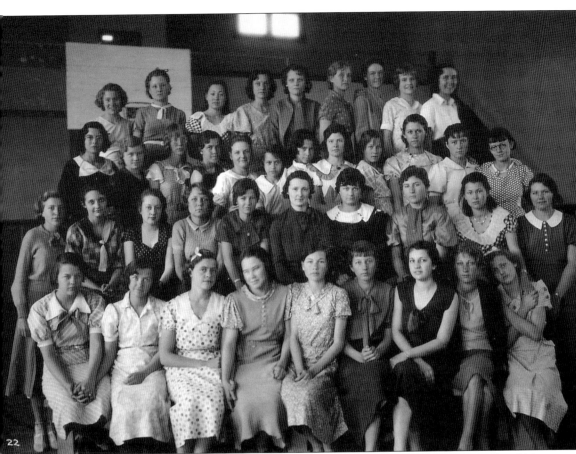

This photograph showcases Hatch High School's home economics club of 1934. During the 1934 graduation ceremonies, a pageant was presented called "The Graduate's Seven Guides." Seniors from the graduating class were chosen to give talks on the value of various vocations in school and their relationship to building character. June Star spoke on behalf of the home economics class. The Hatch Library has taken great care to preserve photographs such as the one seen here. Among their archives are photographs of individual schoolchildren as well as graduating classes from times past. The pride in their organization is clearly seen in both the dress and stature of these young ladies. (Courtesy of Hatch Library.)

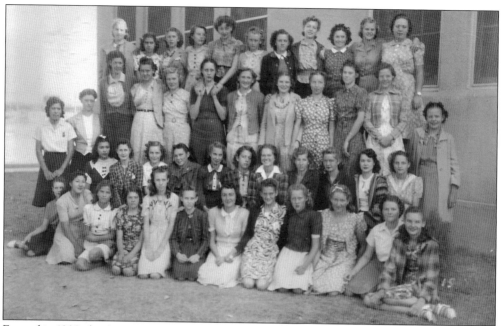

Formed in 1908, the American Home Economics Association lobbied state and federal governments to provide the money needed for economics research and teaching. It is likely that the young girls pictured above (home economics club of 1939) and below (home economics club of 1937) learned the art of patchwork quilting, glass-jar canning, bread baking, and other skills that would help them become homemakers. Interestingly, German propaganda of 1938 Nazi Germany touted that young women would be trained in the art of home economics, as well as being politically aware, in order to eventually raise up a family that would believe wholeheartedly in National Socialism, ensuring that Germany would endure forever. (Both, courtesy of Hatch Library.)

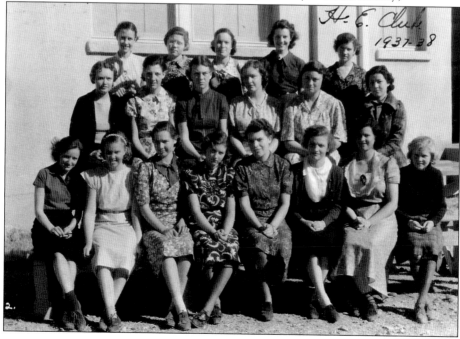

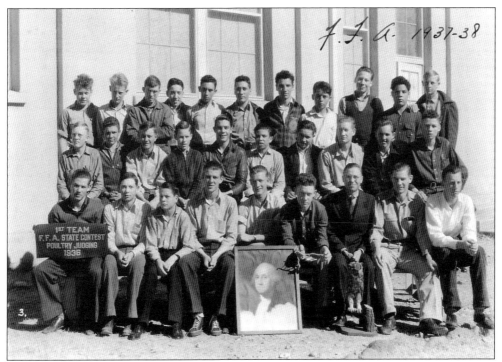

Henry Groseclose wrote the original constitution for the Future Farmers of Virginia, predecessor for today's FFA. He noted that Washington exemplified scientific knowledge, intelligence, and enthusiasm, which were key principles of the organization. The symbol of the owl, long associated with wisdom, represented the knowledge required to be successful in the industry of agriculture. Both symbols are included in the official FFA opening ceremonies today. (Courtesy of Hatch Library.)

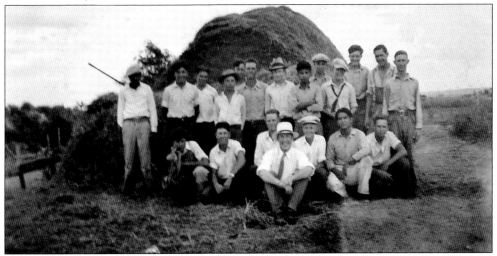

High school teacher Frank Everett Ferguson, the man sitting in the middle with the tie, was around 30 years old when this photograph was taken in 1929. He is either sitting with the Ag class or the Future Farmers of America. Ferguson was born in Colorado and attended Colorado State University, where he was listed as a photographer for the school's 1922 yearbook. (Courtesy of Hatch Library.)

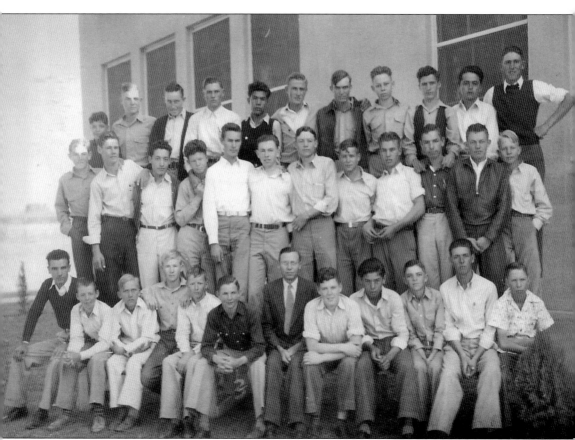

In 1929, Frank E. Wimberly, the state supervisor of agricultural education at the State College of New Mexico, submitted an application for a state charter for a New Mexico Branch of the Future Farmers of America. He listed in his application eight thriving local chapters, one of which was the Rincon Valley Chapter (Hatch) with 21 members. Wimberly noted that it was urgent a charter be granted in order for the boys attending the vocational contest in Kansas City in November of that year to be able to act as New Mexico delegates to the National Future Farmers of America meeting. The image above shows the FFA members of 1939. The class had significantly more members in 1939 than in previous years. FFA promoted vocational education in agriculture in New Mexico public schools, which was supported by Hatch schools. (Courtesy of Hatch Public Library.)

Benny F. Archer purchased Walter Hammel's interest (25 percent) in the Myers Company in Hatch in 1939. He started his own implement company, the Archer Implement Company, in 1943 on the southeast corner of Hall and Franklin Streets after he had convinced the John Deere Company that Hatch would be a good town to open a tractor agency. He expanded his business to sell Buicks, GMCs, Worthington pumps, and other farm implement franchises. He was a charter member of the First Baptist Church in Hatch, having the first organizational meeting in 1939 in his home. His other achievements included serving as Hatch's mayor, serving on the Hatch school board, helping to organize the annual Hatch Valley Chile Festival, and being a member of the local Lion's Club. Archer helped to organize the Hatch Valley Health Center, a rural health center in Hatch. Today, Ben Archer Health Clinics, named after Benny Archer, can be found in Hatch and Truth or Consequences. (Courtesy of Hatch Museum.)

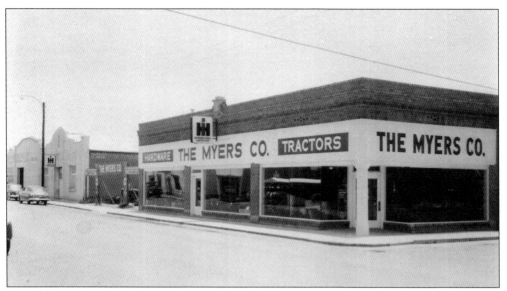

The Myers Company in the village of Hatch advertised International Harvester, Farmall Tractors, home freezers, Dempster Windmills, McCormick-Deering farm implements, hardware, groceries, dry goods, and just about anything else the residents of the Hatch Valley might need. Their phone number was 3 in 1940 and was changed to 2531 in the 1950s. In 1940, the Myers Company opened a gas appliance department at their Hatch store. They also noted that they had a representative in nearby Hot Springs. Looking closely at the far left of the above photograph, the building pictured below has been completed and displays the International Harvester symbol on the front. The two buildings were linked by an outside area where equipment could be parked. (Both, courtesy of Chuck Watkins.)

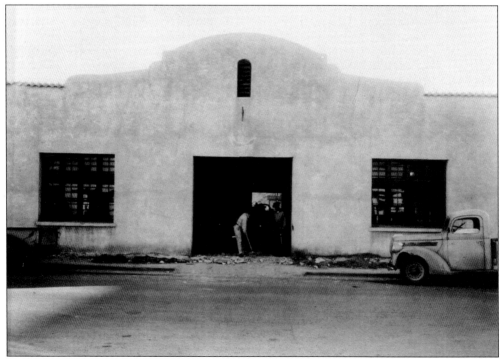

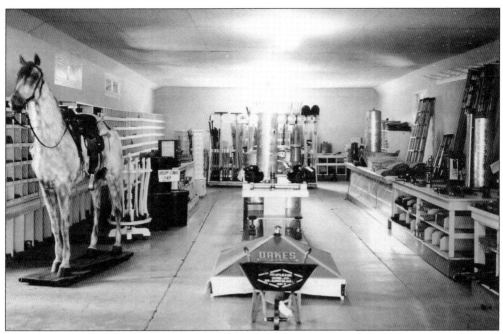

These two photographs show the inside of the Myers Company in Hatch. The original Myers General Mercantile stores were actually a chain of department stores from El Paso, Texas. Small-town mercantile stores carried everything the farmer, businessman, homeowner, or housewife could ever need. Residents in the Hatch Valley did not travel out of their community to shop. During World War II, the military needed gasoline for the war effort and Hatch Valley residents, along with the rest of the United States, faced rationing of gasoline. Automobile tires were also rationed. Shopping locally was commonplace. (Both, courtesy of Chuck Watkins.)

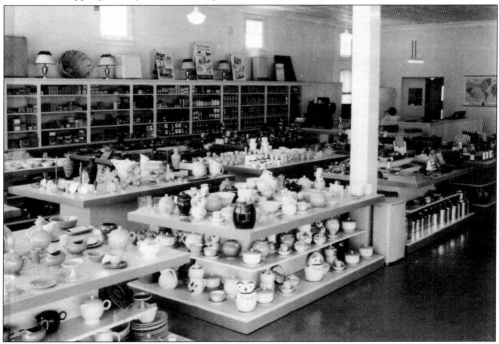

The 1940 US census indicated Frank E. Ferguson was now a principal at Hatch High School. He taught and coached at the high school until his promotion as principal. He would eventually rise to the position of superintendent of the Hatch School District. In 1940, his wife, Ruth, was no longer teaching grade school but was staying at home with their five-year-old son, James. (Courtesy of Hatch Museum.)

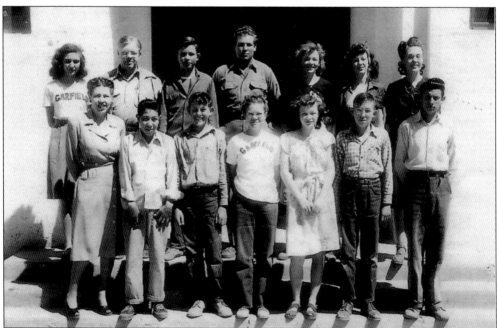

Hatch Valley residents are pictured here standing in front of the Hatch Library. Today, the Hatch Municipal Library is under the direction and care of Lisa Franzoy Neal and has a steady flow of individuals in and out of the building on any day of the week. This fascinating place has a treasure trove of pictures and documents that help preserve the history of Hatch. (Courtesy of Hatch Library.)

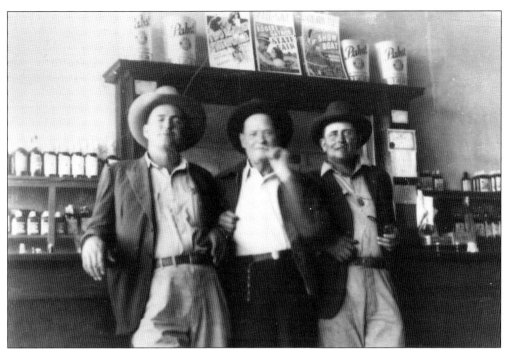

This photograph was taken in the Club Bar, operated by Pop Shields in what was believed to be around the 1930s. From left to right are Clay Hooker, Tony Brooks, and Ray Clear. Both Clay Hooker and Ray Clear would become Dona Ana County deputy sheriffs. Clay Hooker was also with the New Mexico State Police and would participate in the raid of gambling equipment in 1940. (Courtesy of Hatch Museum.)

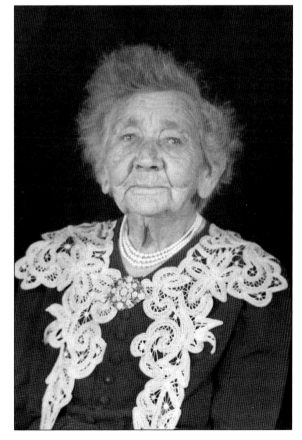

Ellen L. (Foster) Clapp was born November 5, 1854, in Mount Holly, Vermont. She married Lafayette Clapp, and they homesteaded in the Hatch Valley. In her memoirs, available at the Hatch Museum, she writes about her life in the Hatch Valley. Stop in and see Mary Frances Whitlock at the museum and read about early times in the Hatch Valley. (Courtesy of Hatch Museum.)

UNITED STATES
OF AMERICA

War Ration Book One

WARNING

1 Punishments ranging as high as *Ten Years' Imprisonment or $10,000 Fine, or Both,* may be imposed under United States Statutes for violations thereof arising out of infractions of Rationing Orders and Regulations.

2 This book must not be transferred. It must be held and used only by or on behalf of the person to whom it has been issued, and anyone presenting it thereby represents to the Office of Price Administration, an agency of the United States Government, that it is being so held and so used. For any misuse of this book it may be taken from the holder by the Office of Price Administration.

3 In the event either of the departure from the United States of the person to whom this book is issued, or his or her death, the book must be surrendered in accordance with the Regulations.

4 Any person finding a lost book must deliver it promptly to the nearest Ration Board.

OFFICE OF PRICE ADMINISTRATION

No. 798885 -363

War Ration Books were used during World War II. Rationing was a way for those on the home front to support the war effort. In particular, meat, clothing, and gasoline were tightly rationed. American consumers were asked to purchase only what they needed in order to keep supplies from dwindling. The punishment for misusing a ration book was as high as 10 years imprisonment, a $10,000 fine, or both. Pinto beans were one of the items that fell under the rationing guidelines. This caused hardship in the Mexican food restaurants in Hatch, New Mexico. On April 28, 1943, Governor Dempsey, most likely thinking with his stomach, left for Washington, DC, by train to conference with the Office of Price Administration and the Secretary of Agriculture. One of the items on his agenda was to get the government to exclude the pinto bean from rationing. (Courtesy of Jay Carpenter.)

429|390 Q

UNITED STATES OF AMERICA
OFFICE OF PRICE ADMINISTRATION

WAR RATION BOOK TWO

IDENTIFICATION

LEWIS W. PENNINGTON
(Name of person to whom book is issued)

U.S. Route 1-85
(Street number or rural route)

Las Cruces _N. Mex._ _46_ _M_
(City or post office) (State) (Age) (Sex)

ISSUED BY LOCAL BOARD NO. _9_ _Grant_ _N. Mex._
(County) (State)

Silver City
(Street address of local board) (City)

By _Emma Johnson_
(Signature of issuing officer)

SIGNATURE _____
(To be signed by the person to whom this book is issued. If such person is unable to sign because of age or incapacity, another may sign in his behalf)

OFFICE OF PRICE ADM.
R-123

429/390

WARNING

1 This book is the property of the United States Government. It is unlawful to sell or give it to any other person or to use it or permit anyone else to use it, except to obtain rationed goods for the person to whom it was issued.
2 This book must be returned to the War Price and Rationing Board which issued it, if the person to whom it was issued is inducted into the armed services of the United States, or leaves the country for more than 30 days, or dies. The address of the Board appears above.
3 A person who finds a lost War Ration Book must return it to the War Price and Rationing Board which issued it.
4 PERSONS WHO VIOLATE RATIONING REGULATIONS ARE SUBJECT TO $10,000 FINE OR IMPRISONMENT, OR BOTH.

OPA Form No. R-121

History says that residents in Las Cruces did not receive their gasoline ration cards until November 1942. It would be likely that Hatch residents got theirs about the same time. Counties had rationing boards that issued tires to people with urgent needs. Oral history says that farmers were given "some priority" to getting tires for their farm equipment. Home glass jar canning was encouraged by the government to lessen the amount of food rationing stamps needed. New Mexico farmers were asked to increase crops such as beans, peanuts, corn, sorghum, long-staple cotton, and potatoes. If ration books were lost, there was said to be a long wait time to get another. As sugar was rationed, some families pooled their resources to go to Mexico to get their sugar. Hoarding was discouraged. (Courtesy of Jay Carpenter.)

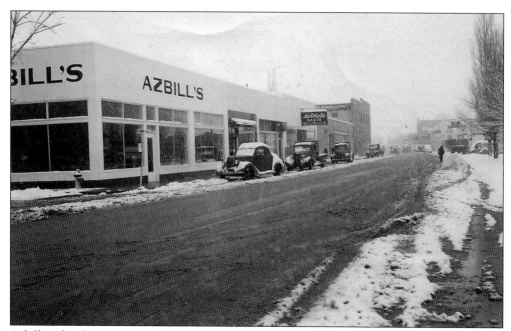

Azbill's, a local grocery store in Hatch, was built in 1947 on the corner of Hall and Main Streets. John Carpenter remembers his mother, Alice, doing business at Azbill's, trading her fresh vegetables for flour, sugar, and other staples she "couldn't grow on the Carpenter family farm." He noted that Azbill's extended monthly credit to most of the farmers in the valley. (Courtesy of Hatch Museum.)

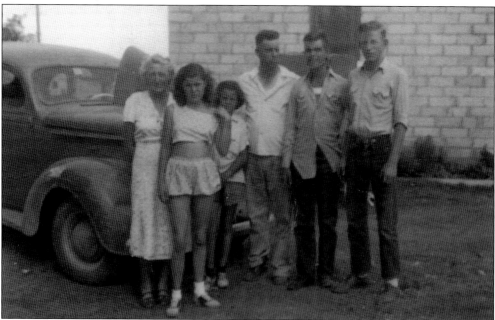

Shown from left to right are Alice, Wilma, Pat, Lester, John, and Lester Jr. Carpenter. Lester Carpenter was a mechanic, and Alice was considered the farmer in the family. The family moved to Hatch after Alice inherited 43 acres from her father, John Lively Vineyard. She loved the valley and was saddened when her health necessitated selling the farm. (Courtesy of Jay Carpenter.)

In 1940, a municipal-owned Butane gas system was in operation in Hatch. Entrepreneurs such as R.B. Clear owned and operated family businesses throughout Hatch's history. This photograph shows the Red Top Texaco Service Station that was owned and operated by Judge Clear from January 1932 until his death in April 1956. (Courtesy of Hatch Museum.)

The *Las Cruces Sun News* reported on January 16, 1946, that the Board of Trustees of Hatch had adopted zoning regulations for the "purpose of promoting the health, safety, morals, and general welfare of the Village of Hatch." This photograph captures Franklin Street in the village of Hatch, looking south from Reed Street, in December 1946. (Courtesy of Hatch Library)

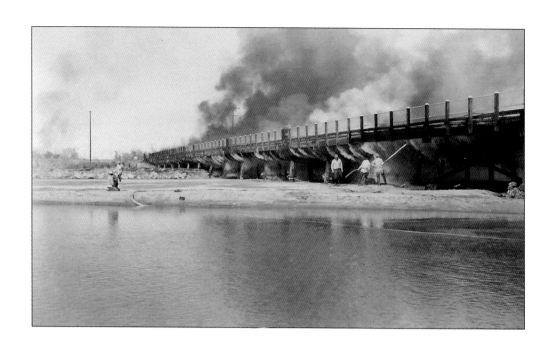

In 1949, the road connecting El Paso, Texas, to Albuquerque, New Mexico, was called Highway 85. Highway 85 had a bridge over the Rio Grande about two miles north of Hatch. This expanse of highway connected Hatch to the neighboring towns to the north of Salem, Garfield, and Hot Springs. This was also the highway in which people from the south were traveling to reach Elephant Butte Lake. On December 28, 1949, the *Farmington Daily Times* reported that a "wee burning fire got out of control yesterday and ignited the north half of the span across the Rio Grande two miles north of Hatch on US 85." No description of what a "wee fire" was or how it got started was given. (Both, courtesy of Hatch Museum)

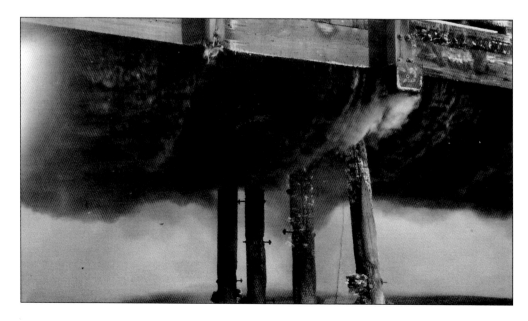

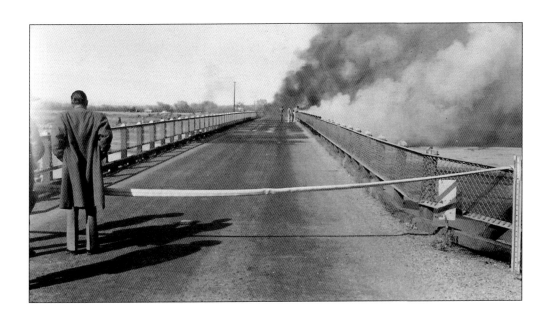

In order to keep traffic flowing north, light vehicles were allowed to detour over a wooden bridge a mile farther north. Heavier vehicles were diverted 170 miles west by way of Bayard, New Mexico, and Deming, New Mexico. According to state police, two auxiliary bridges would be built by the side of the burned span, which would allow for the crossing of vehicles weighing up to 15 tons. No time frame for the building of these bridges was given. Volunteer firemen had abandoned the fight to save the northern portion of the bridge, but had managed to put out the flames that were threatening the southern half of the bridge. A man on a bulldozer was given the instructions to cut the bridge in half in order to save the southern part. (Both, courtesy of Hatch Museum.)

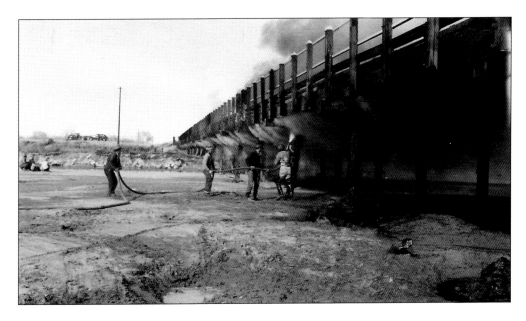

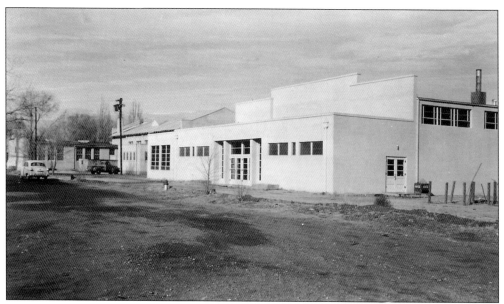

In 1951, Hatch schools were proud to have completed some outlying buildings at Hatch Union High School. The new additions, shown above, included a new gym, band room, and some classrooms. That same year, schools in Hatch, Rincon, Garfield, and Salem were consolidated into one school district, Hatch Valley Consolidated Schools. M.E. Linton was elected superintendent of the newly consolidated school district. (Courtesy of Hatch Museum.)

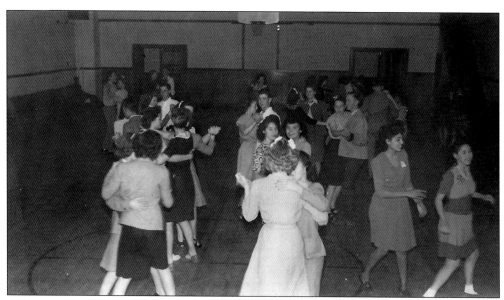

A dance at Hatch Union High School was the highlight of entertainment for Hatch Valley youth. This photograph was taken in the 1940s. Throughout the 1930s and 1940s, "cowboy songs," or Western music, were popular and romanticized the cowboy. Plenty of authentic cowboys could be found in Hatch Valley. (Courtesy of George and Vada Basabilvazo.)

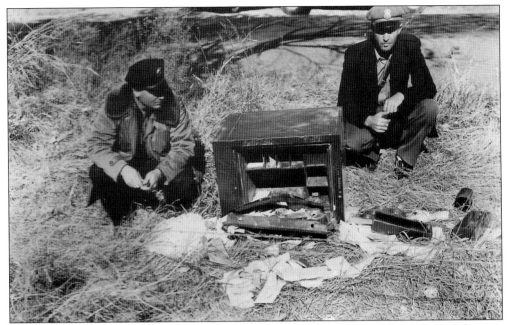

The two individuals in these photographs were identified as being Don Hammond of the New Mexico State Police Department and B.M. "Booze" Mitchell, of Hatch City Marshall. It is estimated that the robbery of the El Paso Electric Company of Hatch took place in 1950. The safe had been taken from the building during the robbery and was found later by law enforcement on the Rincon Highway. It would appear that the money was taken out of the badly damaged safe and the rest of the contents left behind were deemed worthless by the robbers. (Both, Courtesy of Hatch Museum.)

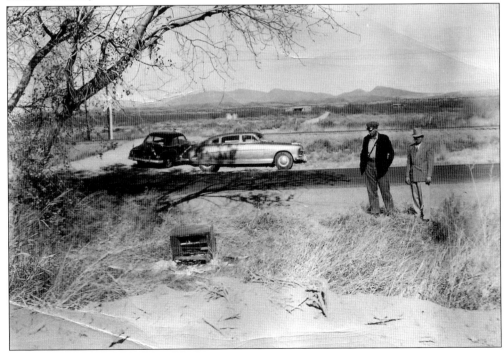

Harmon Black, mayor of Hatch from about 1946 until 1954, was born in Oklahoma. In the 1930 census, he was 23 years old and lived with his parents and siblings in Hatch, working as a laborer on a farm. In the 1940 census, Harmon, his wife, and three kids, continued to live in Hatch, working as the assistant manager in a retail hardware and lumber store. (Courtesy of Museum.)

Judge R.B. Clear owned and operated the Red Top Texaco Service Station in Hatch (also listed as the Texaco Red Roof Station) from 1932 until his death in April 1956. He was also a justice of the peace, according to museum records. In 1930, Clear was living in Oklahoma and listed his occupation as a "commission merchant at a filling station." (Courtesy of Hatch Museum.)

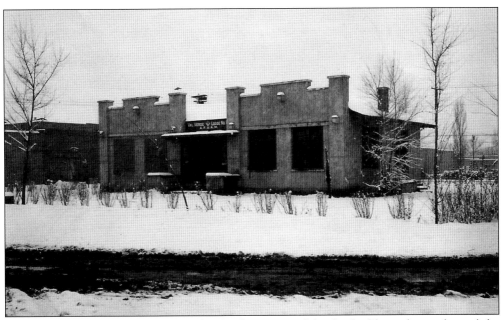

The Masonic Lodge, formerly Central School, was one of the few buildings that withstood the 1921 flood. The Masons met there until 1969. The location of the building is on the north half of the block between Franklin and Price Streets and Hall and David Streets. (Courtesy of Hatch Museum.)

Pictured at the Hatch Airport are Ed Gary, Clyde Jones, Forest Hedgecoch, and Frank Archer. By 1974, the Hatch Municipal Airport was the location of the third annual Hatch Valley Chile Festival. The event was sponsored by the Hatch Valley Chamber of Commerce, and thousands of people were said to have traveled to Hatch to attend. The festival is still celebrated annually in Hatch. (Courtesy of Hatch Museum.)

This c. 1950 photograph shows the employees of the Myers Company. Front and center sits Everitt Bowers, manager of the company. From left to right are employees Chester Berridge, Willard Kelly, J.Q. Barnes Sr. (manager), P.C. Whitlock (mechanic), Howard Leach, and Annie G. Gordon (bookkeeper). (Courtesy of Hatch Museum.)

This photograph looks west on Hall Street in the village of Hatch. It was most likely taken from the intersection of Hall and Franklin Streets. The date of this image is unknown. Western wear, including boots and hats, is still sold in the village of Hatch. (Courtesy of Hatch Museum.)

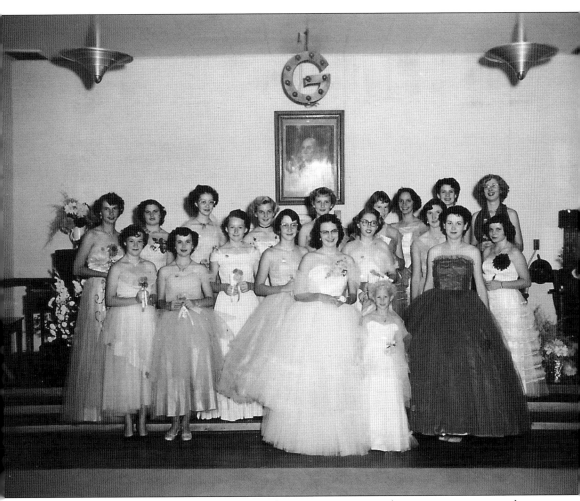

The International Order of the Rainbow Girls was a Masonic youth service organization that taught leadership training through community service work. The order began in 1922 when Freemason Rev. W. Mark Sexson suggested that an order would be beneficial for young girls. Girls were able to hold offices known as stations. The order required girls to memorize certain material, and all but two stations required the individual to serve for one term, which was four to six months long. The Worthy Advisor was the president of the club. In this September 27, 1953, image, Hatch's International Order of the Rainbow Girls are identified from left to right as (first row) Estelle Hartman (installed as worthy advisor), unidentified, and Carylon Cocks; (second row) Patsy Callaway, Peggy Hanna, Patsy Latermer, Phyllis Cocks, Sandie Strong, Jerry Robertson, and Pat Carpenter; (third row) Mary Frances Nance, Wilma Carpenter, Sharon Bowers, Christine Ware, Barbara Funk, Shirley Moeller, Connie Vetter, Pat Morgan, and Ann Jeffers. (Courtesy of Hatch Museum.)

Homer Claude "H.C." Vest owned a shoe repair shop in Hatch and employed Benny Orr, pictured on his scooter. Benny, affectionately known as "Uncle Benny," had physical challenges and needed transportation. Vest bought Uncle Benny this three-wheeled Cushman Scooter to get around town in. This photograph was taken near the Hatch Union High School. (Courtesy of George and Vada (Vest) Basabilvazo.)

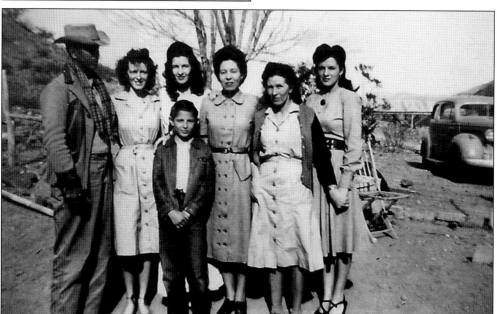

Pictured from left to right are members of the Vest family: Homer Claude "HC," Opal May, Claudia, El Jean, Opal, and Vada. The little tomboy in the front was daughter Elsie. The Vest family lived in Spring Canyon, which was due south of Hatch. Spring Canyon had the notoriety of being one of two places that flooding originated from; the other was Placitas Arroyo. (Courtesy of George and Vada (Vest) Basabilvazo.)

Henry Hall was living in Colorado (now Rodey), New Mexico, in 1900, when he was six years old. His father, Thomas Hall, was a cattle grower. In 1920, Henry was living in Hatch and also listed his occupation as a cattle grower. In 1930, however, Henry was listed as a manager in a retail grocery store. (Courtesy of Hatch Museum.)

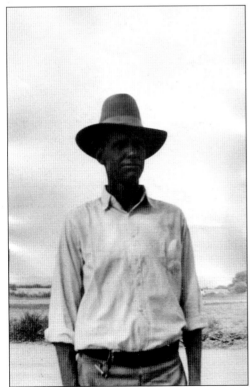

Thomas C. Hollowell was a Hatch merchant who owned and operated the Hollowell Store on the southwest corner of what is now Main and Hall Streets. He was appointed postmaster in Hatch on May 20, 1920. Hollowell enlisted in the Army on April 3, 1919, and served during World War I. (Courtesy of Hatch Museum.)

Residents were confused by new fishing laws, so clarification was made in the *Rio Grande Republican* on September 17, 1909. No fishing could be done between 9:00 p.m. and 4:00 a.m., and nonresidents were required to pay $1 for a fishing license. Further information indicated, "There is some difference of opinion as to the meaning of the law in referring to seines, trot lines, etc., some believing it to mean all fish and others just the game fish. The law on this subject reads: ' . . . nor shall any person use in the pursuit, taking, wounding or killing any animals, birds or fish protected by this act, any net, seine, trap . . . ' It will be noticed that the law says 'protected by this act' and only game fish are protected by the act." For those individuals who took fishing to a different level, it was cautioned, "dynamite and other such inventions of the devil may not be used in any lake or stream." This photograph, taken from the Hatch Syphon, is of the Rio Grande. (Courtesy of New Mexico State University Library, Archives and Special Collections.)

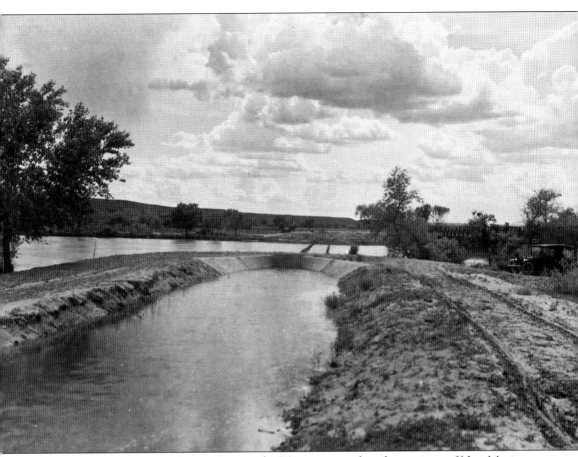

In 1909, a general hunting license (costing $1.50) was required in the territory of New Mexico. The September 17, 1909, issue of the *Rio Grande Republican* reported the following: "A game warden may take your horse and rig and take game unlawfully in your possession to some place where he [game warden] can sell it. He can also haul you to the cooler in your rig and you cannot collect livery hire. He may demand to see your hunting license at any time. A license may be revoked [if] the holder knowingly violates the game law. No game may [be] pursued or taken with a steel or hard pointed bullet . . . anyone hunting out of season or killing protected game, the territorial warden may bring civil suit in the name of the territory against a hunter for injuring or killing protected game. The minimum amounts for which suit may be brought being as follows: For each elk, mountain goat or mountain sheep, $200. For each antelope, $100. For each deer or beaver, $50. For each bird, $10." (Courtesy of New Mexico State University Library, Archives and Special Collections.)

Lion's (possibly spelled "Lyon's") Point, shown above, was a popular park and picnic area built at the top of Spring Canyon, just outside of the village of Hatch. The area was especially popular with nearby residents during the Fourth of July celebration. From the vantage point of the park, the majestic mountain ranges were referred by the locals as, from left to right, the Little Caballos, the Big Caballos, and McLeod Hills (Red House Mountain). From this point, visitors to the area would be able to see the train tracks running through the valley. The middle cluster of trees would have been where the train depot for the Hatch Station was located. Oral history says the Cub Scouts had weekly meetings in the old train depot at one time. The views would have been breathtaking from this spot. (Courtesy of Hatch Library.)

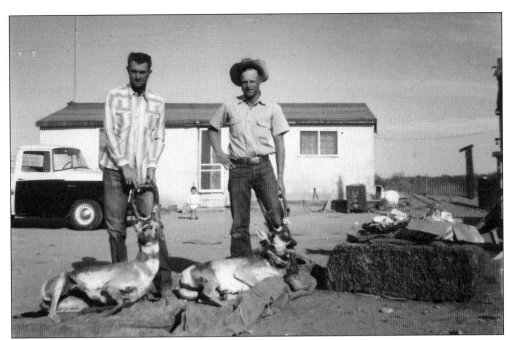

These antelope hunters are Joe Paul Lack Sr., left, and James Franzoy. Antelope have even-toed hooves and are known for their long strides while running. They are called ruminants, as they have well-developed molar teeth that grind cud (food balls stored in the stomach) into a pulp for further digestion. Good eatin'! (Courtesy of Joette Mays.)

Jim Woods, known as Reverend Woods, came west from Pennsylvania while trying to get relief from his consumption (tuberculosis). When his vehicle broke down near Hatch, he decided to make it home. Known as a gifted mechanic, he at one time worked for Benny Archer, but eventually owned his own garage. This faithful man of God started the Church of God in Hatch. (Courtesy of Rachel Carpenter.)

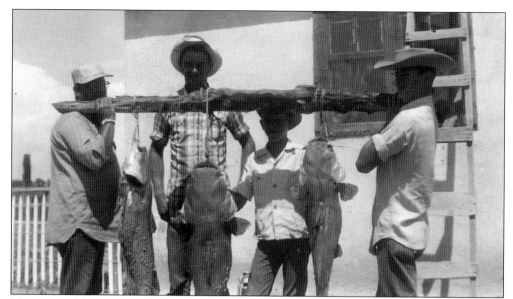

Hunting and fishing were traditions in the Hatch Valley—not only for recreation, but also for the food it provided to families. Pictured above from left to right are Don Looney, Joe Paul Lack Sr., Gene Bates, and Weldon Norville. These catfish were caught in nearby Elephant Butte Lake and provided a big catfish dinner for all involved. Pictured below is an unidentified man posing with an elk harvested by Joe Paul Lack Sr. The photograph was taken at the old Lack Homestead in Salem, New Mexico. Lack was an avid hunter, fisherman, and trapper in the Hatch Valley. (Both, courtesy of Joette Mays.)

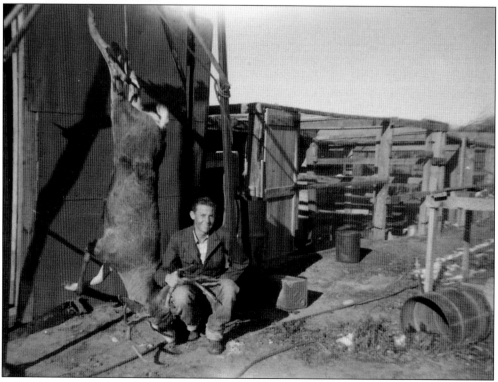

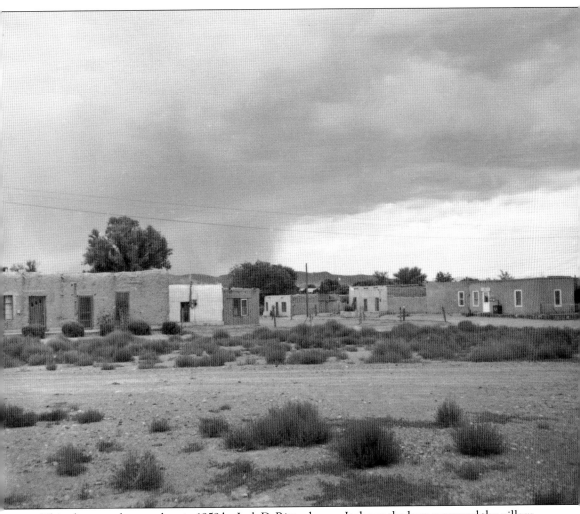

This photograph was taken in 1959 by Jack D. Rittenhouse. It shows the homes around the village plaza in Rodey, New Mexico. Jack Rittenhouse served as president of the New Mexico Historical Association. He was known as an historian, writer, researcher, publisher and photographer. Mr. Rittenhouse published materials through his company called the Stagecoach Press. In 1967, he was the curator at the Laboratory of Anthropology (Research Division of the Museum of New Mexico) and his work in the fields of anthropology and archaeology were available for sale through the museum. This particular Rittenhouse photograph gives a glimpse of the community of Rodey as it stood in 1959. Formerly called Colorado, this quiet town has forever lived in the shadow of the village of Hatch. (Courtesy of New Mexico State University Library, Archives and Special Collections.)

These photographs show the grand opening of Western Bank in the village of Hatch in the year 1968. Buster Halsell and Lucy Beth Graham are said to be facing the camera in the photograph above. In the image at left, the short man is identified as R.V. Ware. A much younger Ware can be seen on page 49 standing on a dirt road in front of the Hatch First National Bank Building,. R.V. Ware operated the bank from the post office until the bank's new building could be completed in the early 1920s. (Both, courtesy of Hatch Museum.)

Four

FARMING IN
HATCH VALLEY

Farmers in the Hatch Valley had found the "promised land." The *Rio Grande Farmer* reported on December 13, 1923, that "alfalfa, wheat barley, oats, corn, milo . . . all give excellent yields. Cotton has been successfully grown and proved extremely profitable the past season. All ordinary truck vegetables do extremely well and cabbage, onions, sweet potatoes, spinach, melons and beans are profitably grown. Apples, grapes, peaches and pears of very fine quality are grown. This section seems particularly adapted to apple growing." Elephant Butte Dam had been built and promised some relief from flooding and a more consistent irrigation source for the valley. Floods had come but the valley continued to be rebuilt. The reality that water would continue to be an issue was reported in the July 23, 1947, *Las Cruces Sun*: "Although farmers have enough water this year with no rationing, they have been asked to limit their use to three acre feet per acre. It is impossible to predict how much [water] will be available in 1948 . . ."

Farmers in the Hatch Valley, however, were pioneers. They worked hard and prospered. They knew their soil was fertile, their climate was good, and their determination was unlimited. They found new crops and new markets. Green and red chile did not push cotton out the door, only to the side. The Hatch Valley was blessed, and times were good.

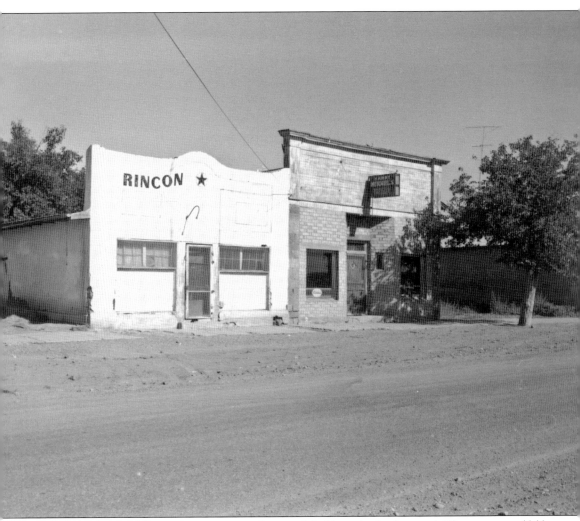

As the Hatch Valley took center stage, Rincon faded into the background. There was an alfalfa named the Rincon Alfalfa, which was developed by researchers at New Mexico State University's Agricultural Experiment Station to be specially adapted to the southern third of New Mexico. It had a low level of resistance to bacterial wilt. The same could be said about Rincon; it refused to just wither and die. Farmers in and around the town of Rincon continue to call it home. In 1977, a delegation from the Rincon Valley appeared at a public meeting with farmers of the Mesilla Valley. The meeting was set up by the Bureau of Reclamation. Farmers testified against a plan to enforce a 1902 provision that would limit irrigation tracts to 160 acres. Water continues to be an issue in the valley to this day as large commercial farms remain viable in the area. (Courtesy of New Mexico State University Library, Archives and Special Collections.)

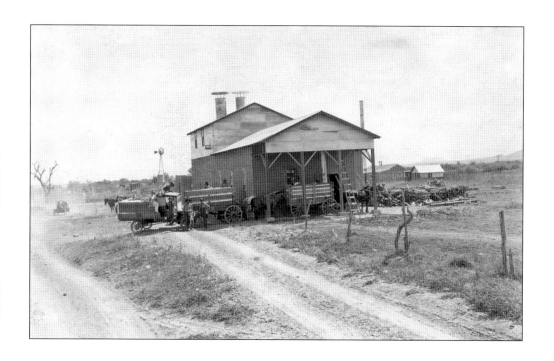

These two photographs show the same cotton gin in early Hatch Valley. Although the photographs look to be the same, there are subtle differences between the two. In the above photograph, the men are looking at the camera. As they turn their heads from the camera, the photographer took the picture below. As the wagon full of cotton pulled in, a vacuum tube would suck the cotton out of the wagon and into the saws. The saws would remove the seed from cotton, separating the cotton and the cottonseed. The seed would then be separated into the seed bin, leaving seeds for the farmers to buy back for next year's crop. (Both, courtesy of New Mexico State University Library, Archives & Special Collections.)

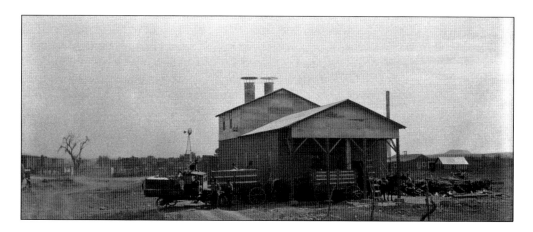

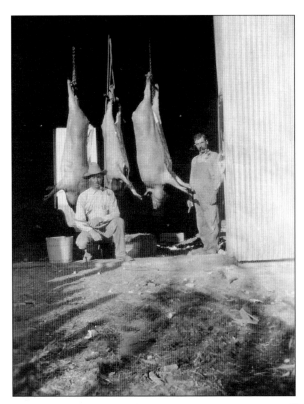

According to the *Rio Grande Republic* of November 30, 1917, Hatch Valley was attractive to stock raisers. It was noted that "Our conditions [Hatch Valley's] are ideal for all kinds of stock raising; hogs, especially, do well; also poultry conditions are all that could be wished for." (Courtesy of Bobby Franzoy.)

Cabbage is being loaded on to railroad cars headed for market in this image. Oral history says that Alex Franzoy was one of the first farmers in the valley to grow vegetables commercially. The *Rio Grande Farmer* edition of June 14, 1923, indicated that the cabbage market was bringing $80 a ton. It was predicted in the article that cabbage would be in short supply that year. (Courtesy of Bobby Franzoy.)

The *Rio Grande Farmer* said on December 13, 1923, that the "dairy and poultry industries are in their infancy in the Rincon valley. To those who are now engaged in them they are proving profitable and with the excellent markets available they should be extensive, followed both as specialties and as side lines to general farming." Chickens provided not only eggs, but also the occasional fried chicken dinner. The *Roswell Daily Record* of May 30, 1923, ran an article that said, "Practical tests clearly show that more eggs result with artificial illumination." The article continued, "Keeping the hens awake by placing electric lights in the hen houses has been tested in actual use so long that it can now be described as an accepted practice among many poultrymen." (Both, courtesy of Bobby Franzoy.)

Early in the Hatch Valley, horses were used to plow the fields, plant the crops, bring in the hay, pull wagons, and other hard labor jobs. Good horses were assets to farmers. In the 1920s, only a few farmers actually owned tractors. As the times changed, more and more farmers began using modern machinery, and horses lost their jobs. Then came World War II, and as the *Clovis News Journal* reported on August 25, 1941, "Horses and mules, once considered casualties of the gasoline age, soon may be back to work helping to rearm America." The Army had purchased approximately 27,000 horses in 1940. By 1941, they had 9,000 more in "remount" depots waiting to be assigned to units. (Both, courtesy of Bobby Franzoy.)

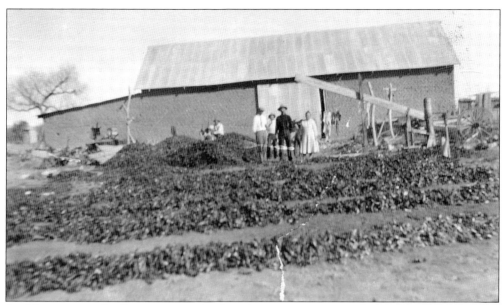

Oral history says the Franzoys were the first farmers to commercially produce chile in Hatch Valley. In 1926, less than 300 pounds of chile had been marketed in the entire Rincon Valley. By 1929, about 250,000 pounds of chile was being sent to market, bringing farmers 10¢–15¢ a pound. Unfortunately, according to the *Las Vegas Daily Optic* of January 17, 1929, the crop was "far from the best because of the lack of uniformity in variety and the mixing of grades." In 1929, an acre of cotton could bring a farmer about $100. An acre of chile was bringing $250. Both photographs show red chile on the Franzoy farm being laid out to dry for market. Eventually, chile dehydrators would enter the valley and mechanize the drying of the chile. (Both, courtesy of Bobby Franzoy.)

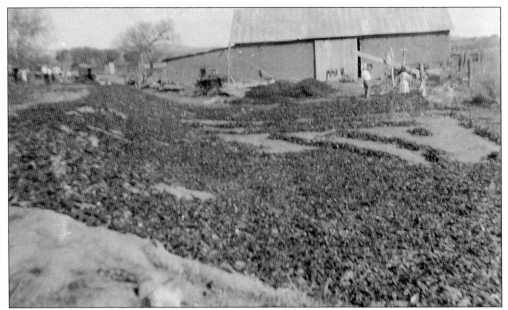

On June 9, 1914, the *Rio Grande Republican* ran an article by Fabian Garcia, who noted that the "chile plant is well suited to New Mexico condition." Garcia also wrote that the chile plant had been grown in New Mexico "for a long time." This photograph shows the red chile being laid out to dry. (Courtesy of Bobby Franzoy.)

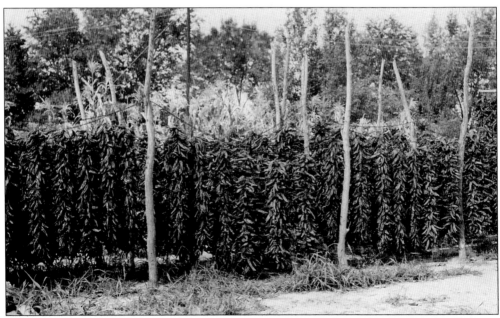

Chile ristras were a way to preserve the chile for future use in dishes such as enchiladas, chili con carne, or burritos. Ristras were made by taking wire and hooking the stems of five or six fresh red chiles into a cluster and working down until a length of four to eight feet of ristra had been obtained. (Courtesy of Bobby Franzoy.)

This photograph shows the back of a truck containing tow sacks with vegetables, perhaps potatoes, being taken to market. The scale in the back of the truck allowed the farmer to weigh his product for selling. In 1919, New Mexico farmers were said to grow fewer potatoes, hay, apples, and beans than in 1917. No reason was given for the reduction in these crops. (Courtesy of Bobby Franzoy.)

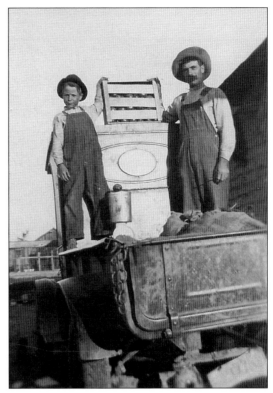

Between 1891 and 1916, a one-piece work overall in tough cotton designed to fit over one's shirt and trousers became popular for the working class. In the 1930s, overalls were used as comfortable children's clothes and were made from denim. All over America, farmers used them for protective overgarments. These future farmers of the Hatch Valley were no exception. (Courtesy of Bobby Franzoy.)

Picked cotton was dumped into the back of this 2.5-ton International truck to be delivered to the cotton gin. The loaded truck would be weighed on the scales before pulling into the area, where a vacuum tube would suck out the cotton. After the truck was emptied, it would be weighed again so the cotton farmer could be credited for his cotton. (Courtesy of Bobby Franzoy.)

In the late 1940s and early 1950s, the Hatch Valley was experiencing a drought. The impounded water from Elephant Butte Dam was said to have dropped below 10,000 acre feet. Farmers had to drill irrigation wells like the one shown above in order to get water to their crops. (Courtesy of Bobby Franzoy.)

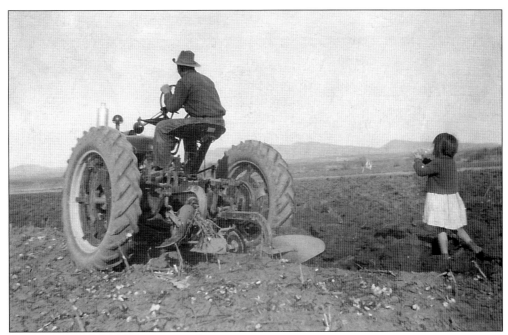

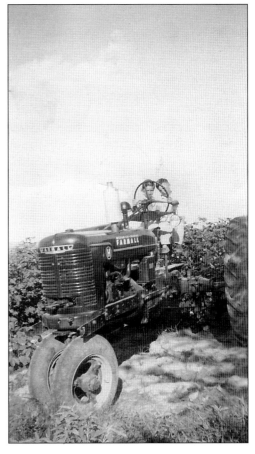

Invented in the 1920s, the one-way disc plow, shown above on a Hatch Valley farm, incorporated stubble (crop residue) into the upper layer of the topsoil. The stubble served as mulch and helped to conserve precious moisture while reducing erosion of the soil by wind and water. Before this invention, farmers had plowed stubble under or burned it. (Courtesy of Bobby Franzoy.)

Future Hatch Valley farmers sit atop a Farmall H series tractor. Farmall tractors were originally painted a deep blue-grey with red wheels. In 1936, the company decided to change the entire tractor, including the frame, sheet metal, engine and wheels, to "Farmall Red." The color red kept the tractor noticeable from a distance and was a great advertisement for the brand. (Courtesy of Bobby Franzoy.)

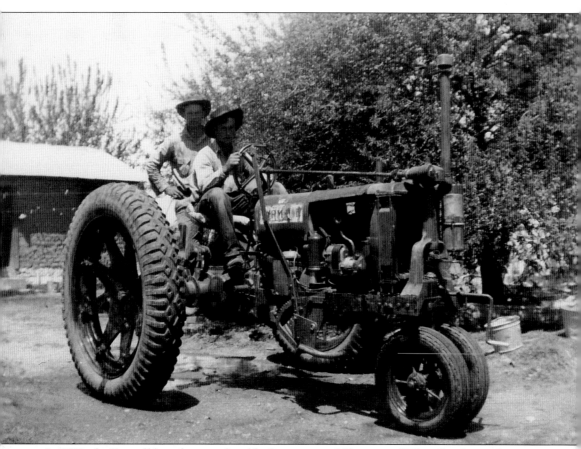

In 1932, the Farmall brand was updated by International Harvester (IH) with a bigger, heavier, and more powerful engine known as the F20. The demand for a lower cost, all-purpose tractor that was a smaller version of the F20 resulted in the production of the McCormick-Deering Farmall F12. The F12 had no portal axle in the rear and gained its height through its larger-diameter wheels (54 inches). The 113ci Waukesha L-head, four-cylinder gasoline engine was used the first year of production. The F12 was also about a 1,000 pounds less in weight than the F20 and more than a foot shorter. The large wheels gave good ground clearance without the need for the drop gears of the F-20. In 1934, the company produced 12,530 F12s, and produced 35,681 in 1937. This photograph of two Hatch Valley farmers sitting atop a Farmall F12 is thought to have been taken in the late 1930s or early 1940s. (Courtesy of Bobby Franzoy.)

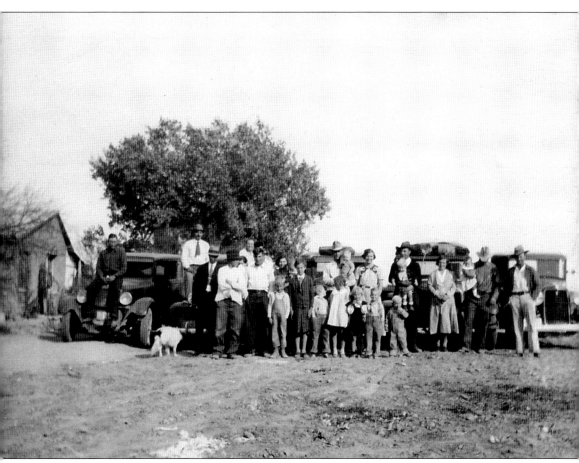

The *Rio Grande Republic* reported on October 12, 1917, that "Uncle Sam" would save the valley. According to the article, "Seepage, due to a large extent to an excessive and unscientific use of the water afforded by the Elephant Butte Dam project, is causing serious damage to crops and has already destroyed thousands of fruit trees and injured hundreds of acres of alfalfa." In essence, farmers had overwatered their crops. It was proposed to farmers that a government irrigation district would be formed and that farmers would accept the federal contract to tax the land to cover the expenses incurred. The farmers agreed, and the Rio Grande Project began. The hope was that water could be delivered "onto the lands from the main canal in a more direct manner, avoiding to a large extent the slow movement of water which results in saturation and induces seepage." Hatch Valley farmers and their families, such as the ones pictured above, benefited from that crucial decision of 1917. (Courtesy of Bobby Franzoy.)

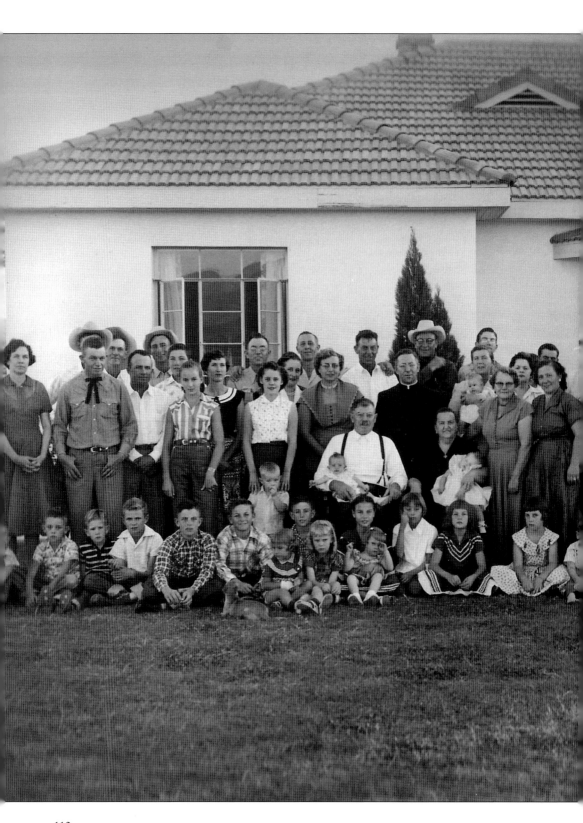

Joseph Carlo Franzoy of the Hatch Valley and his wife, Celestina, are shown celebrating 50 years of marriage with their family. Joseph homesteaded along the Rio Grande near Hatch Station (later shortened to Hatch) in the early 1900s. Joseph emigrated from Austria to the United States in January 1905. According to great-granddaughter Liza Franzoy Neal, Joseph's first bite of hot green chile led him to believe he had been poisoned. He was undeterred by this first encounter, and chile became his cash crop. His descendants continue his legacy of chile farming in the Hatch Valley. Green chile as well as red chile is grown by the Franzoy family. The question is, "Red or Green . . . How do you like your chile?" Both varieties can be bought in the Hatch Valley. (Courtesy of Dorothy Gillis.)

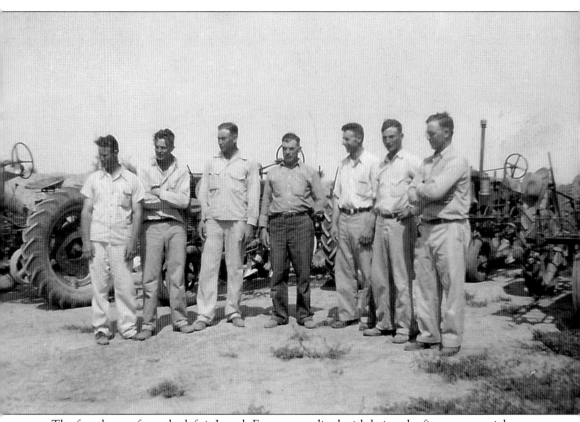

The fourth man from the left is Joseph Franzoy, credited with being the first commercial grower of chile in the Hatch Valley. He is surrounded on both sides by his sons. In the *Rio Grande Republican* of June 9, 1914, Fabian Garcia gave the following advice to chile farmers: "After the land has been thoroughly prepared, the rows may be marked off; usually by plowing out a small furrow with a small plow, which is used for irrigating the plants, the transplanting being done on the side of this small furrow. As the plants grow and the middles are cultivated, the dirt is pushed over towards them, so that by the time they begin to bear they are practically in the middle of a ride. It is considered a good plan to cultivate in such a way as to throw the dirt towards the plants as they grow. The later irrigations are then given through the furrows or between the ridges. The chile plant will produce as long as it is kept growing vigorously." (Courtesy of Bobby Franzoy.)

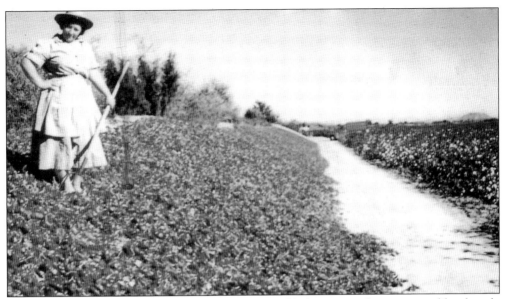

Red chile production in the Hatch Valley was profitable but required patience and hard work. The chile was spread out on the ditch banks to dry and was turned often in order to expose all sides of the red chile to the sun. The photograph above shows Hatch Valley farmer Tessie Franzoy with her rake, stopping just long enough from her busy job of turning the red chile to pose for a picture. The photograph below shows Tessie's daughter Louise separating the chile and getting it ready to be placed in the tow sacks. According to Louise, the sacks would be hauled back to the barn and would later be sold to customers. The production was a family affair, with everyone chipping in to get the job done. (Both, courtesy of Louise Benvie.)

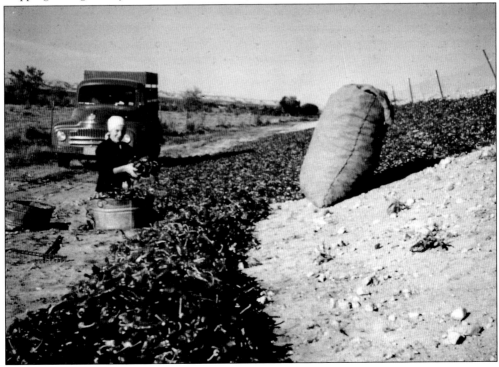

The irrigation systems created by the Rio Grande Project served the farmers well for many years. Both of these photographs show components of the irrigation systems within the Hatch Valley. However, as time went on, the old ditches wasted water and space, occupying many hours of the farmers' time as they had to be cleaned out. James Lytle of Salem came up with a solution by designing a rectangular cement ditch that was 36 inches wide inside and 33 inches deep. This allowed him to release four acres of his farmland from ditch use and turn the land back into production. Lytle built and constructed the new concrete ditches himself with the help of his wife, June. He was quoted as saying, "The time I used to spend cleaning and repairing the old ditch, I can now use in more productive work." Lytle's ditches were successful and copied by many other farmers of the valley. (Both, courtesy of Bobby Franzoy.)

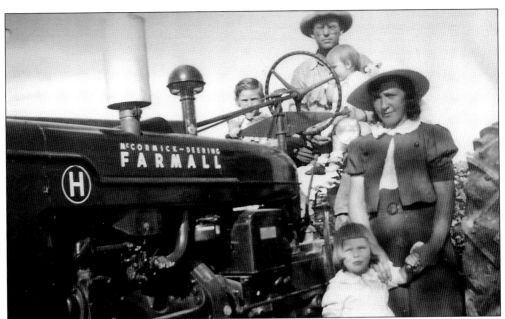

A new tractor was just as good a reason as any to get the family out for a photo op to celebrate the moment. International Harvester produced over 390,317 McCormick-Deering Farmall H series tractors. There were five forward gears and one reverse gear. The 152-cid, four-cylinder engine came with a six-volt electrical system. (Courtesy of Sherry Russell.)

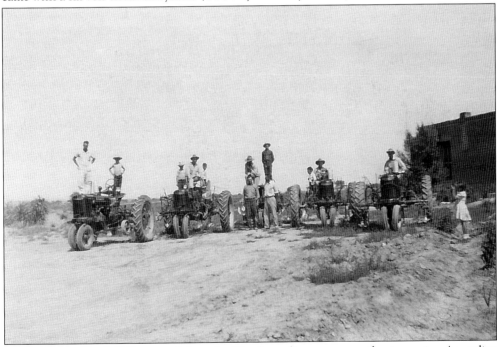

Early on in the Hatch Valley, it took large families depending on one another to survive. According to Rory Carson, the 10 children of Joseph and Celestina Franzoy worked together as a unit to help each other when needed. Hard work was expected, and it was given day in and day out. Here, the boys show off their tractors for the camera. (Courtesy of Bobby Franzoy.)

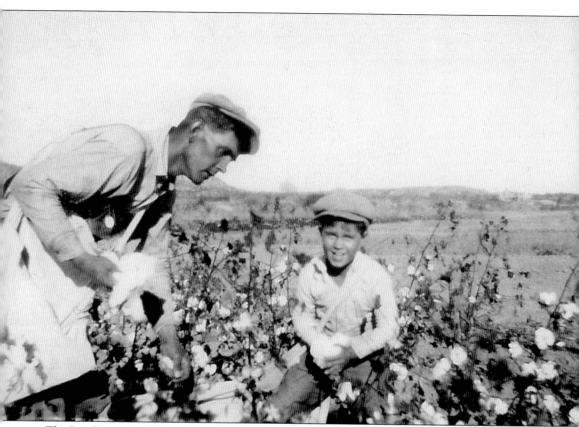

The *Las Cruces Sun-News* of June 14, 1942, ran the headlines "Yank Bombers Aid Reds In Battle Of Russia" and the "U.S. Air Force and Navy Hunt Japs in Aleutian Islands." A joint committee that was representing the farmers, the schools, and Las Cruces businesses worked to draft a proposal to use the school children to pick the cotton if the farmers working on the labor shortage failed to obtain "extra field hands from old Mexico." Families worked together to get the cotton in, but more hands were needed. Hatch superintendent F.E. Ferguson raised a number of objections to this proposal. Psychology professor Claude C. Dove weighed in on the issue, saying, "two months of vacation in winter time—even the loss of that much time—is not going to cripple children's education." "If I were a teacher in the public schools," he added, "I would be ashamed to admit that I couldn't educate boys and girls in patriotism enough to enroll them as cotton pickers in a crisis like this." (Courtesy of Bobby Franzoy.)

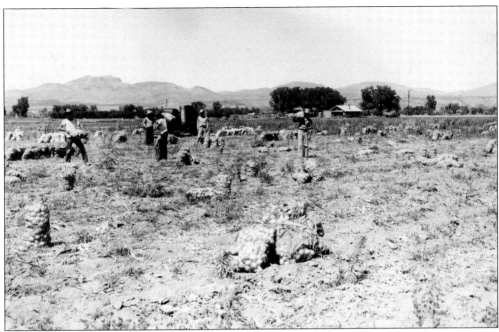

On June 12, 1942, the *Las Cruces Sun News* reported a shortage of migrant workers due to "cots to the Army or to war industry or by automobile and tire rationing." Schools asked to have flexible schedules to allow children of the Hatch Valley to work the fields. Family members worked together to get the onion crop in, as shown above on the Riggs' farm. (Courtesy of Dorothy Gillis)

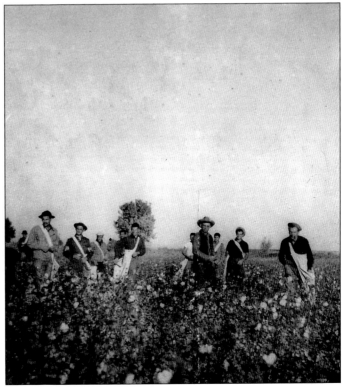

The fourth man from the left, standing in the cotton field in a cowboy hat, is identified as Alex Franoy. According to his daughter, Hatch Valley resident Louise Benvie, Alex is supervising prisoners of war that have been contracted from the Army to pick cotton from his fields. Prisoners were housed in Hatch at a former CCC Camp building. (Courtesy of Bobby Franzoy.)

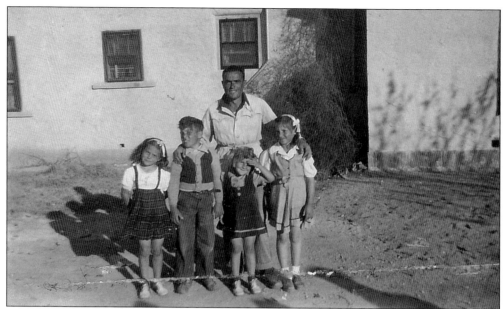

During World War II, the Army announced that German and Italian POWs would be available for contract labor to the farmers (farmers paid the Army for the labor). A POW camp for German and Italian prisoners was established across the street from Hatch High School. Some POWs, like the Italian shown above with Irene, Robert, Mary, and Louise Franzoy, became close friends with farmers. (Courtesy of Bobby Franzoy.)

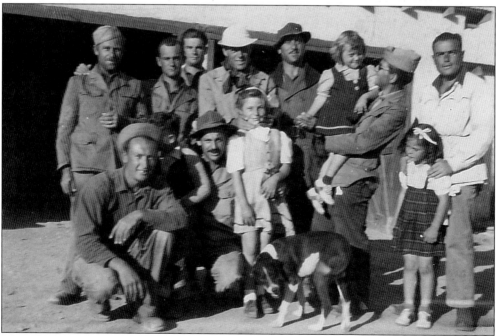

This photograph shows the camaraderie that many of the farmers felt toward the men they knew were prisoners of war from both Germany and Italy. The group pictured here consisted of farmers, the children of farmers, and prisoners of war. Oral history says that the Italian POWs were considered more "likeable" than the German POWs. (Courtesy of Bobby Franzoy.)

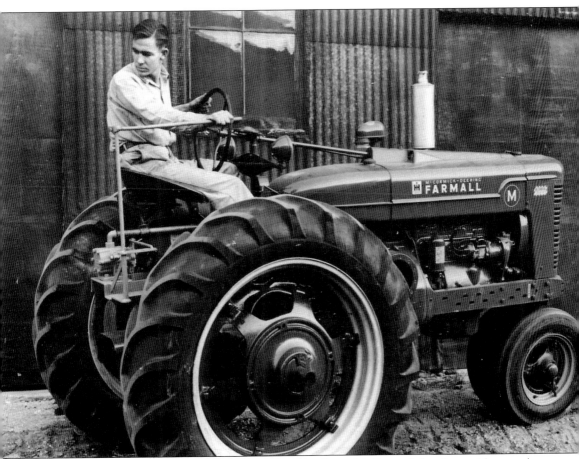

The International Harvester Company was formed by Cyrus McCormick Jr., along with several other leading equipment manufacturers on August 12, 1902. Their new company had a 95 percent market share in harvesting implements. The new McCormick Farmall tractor was developed in 1919. By 1922, it was said that Farmall was the tractor that industrialized the United States. When they started making their tractors red instead of the familiar gray color, it was said to mark the beginning of "Big Red." The tractor above was the M series and was produced by International Harvester from 1939 to 1952. There were over 250,000 of these tractors sold. The Farmall M was the largest row crop tractor at the time made by International Harvester. The Farmall M had five forward gears and one reverse gear. The diesel version of the M tractor was introduced to the farming world in 1941. It would start on gasoline and then, when warmed up, switch over to diesel. (Courtesy of Chuck Watkins.)

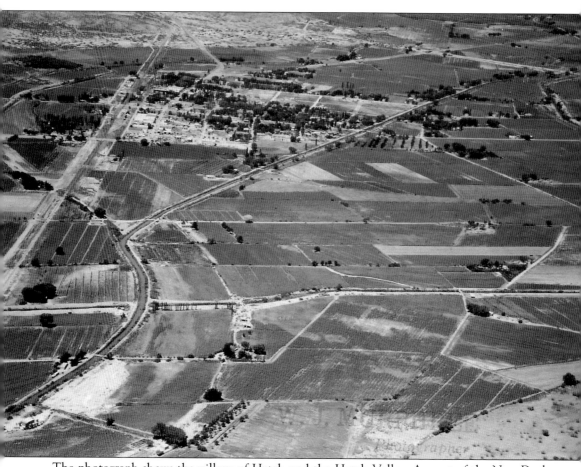

The photograph shows the village of Hatch and the Hatch Valley. As part of the New Deal Era, a United States federal law called the Agricultural Adjustment Act (AAA) was developed to pay farmers subsidies not to plant on part of their land and to kill off excess livestock. The purpose of the law was to reduce crop surplus and raise the value of crops. The subsidies were generated through an exclusive tax on companies that processed farm products. The *Clovis News Journal* wrote on June 2, 1939, that Sen. Carl Hatch, a Democrat from New Mexico, had asked Congress to direct the agriculture department to make all 1938 benefit payments to farmers and stop delaying the payments because it was "destroying the faith of farmers in their government." (Courtesy of Hatch Museum.)

Pictured from left to right are (first row) June holding Faron Raymond, and James Lytle; (second row) Sherry Ann; (third row) Patsy, and Jimmy Joe. Oral history says that James Lytle, known as "Big Jim," built the first chile dehydrator in the state of New Mexico. Big Jim also worked closely with Roy Minoru Nakayama of Las Cruces, known as "Mr. Chile," to develop a new variety of chile. Unfortunately, Big Jim died before the chile was introduced. In his honor, Nakayama named the new variety NuMex Big Jim. In 1975, it was considered the world's largest chile, as it averaged 7.68 inches in length and 1.89 inches in width. It was a little hotter than the chile named New Mexico 6-4, but not as hot as the Sandia. Mexican cooks touted it as being the perfect chile for the New Mexico favorite chile rellenos, which are made by blistering the skin of the chile and removing it, stuffing the chile with cheese, dipping the whole thing in a special batter, and frying it in oil. (Courtesy of Sherry Russell.)

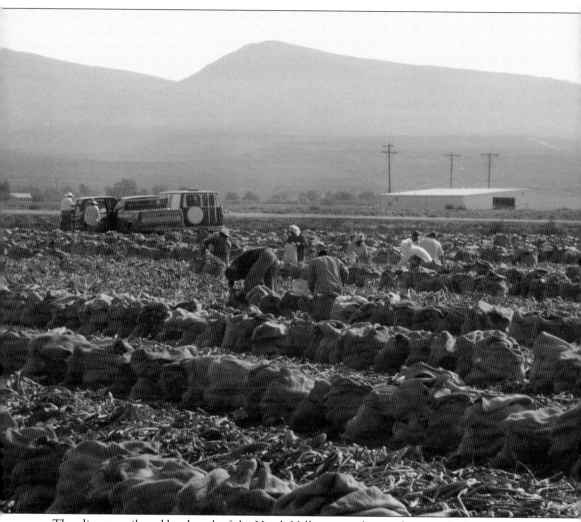

The climate, soil, and hard work of the Hatch Valley onion farmers have made the onion a crop that is well suited for the area. Onion packing plants are also in the valley, shipping onions to all parts of the United States. Physicians commented on the use of onions to cure what ails you as early as the sixth century. During the Middle Ages, onions were cultivated in Europe. It was used as a flavoring for cuisine and also as an herbal remedy for a wide variety of human elements. Native Americans grew not only maize and beans, but also onions. It was said that the pilgrims most likely brought onion seeds over with them on the Mayflower. Mechanical onion harvesters are available, but oftentimes, the onions in the Hatch Valley are harvested by hand. Onions, the Hatch Valley burritos, tacos, and enchiladas thank you for your contribution to the valley's Mexican cuisine. (Courtesy of Joe and Rosie Lack.)

The *Rio Grande Farmer* reported the following on September 27, 1923: "Miss Laura Walker of the Kansas City court of appeals is leveling 30 acres of land near Rincon, which she will seed to hairy Peruvian alfalfa next year. B.B. Roenig will have the job under contract." Alfalfa is a type of hay, which is grass that has been cut and dried. Alfalfa is green (not dried), which means alfalfa hay is the plant cut and dried. By 1930, a cooling station (area where the raw milk could be kept cooled and stored) was to be erected in Hatch at a cost of $25,000 by Midwest Dairies Incorporated. Owners predicted a payroll of more $100,000 per year. The alfalfa hay industry is still in operation on many Hatch Valley farms. (Courtesy of Joe and Rosie Lack.)

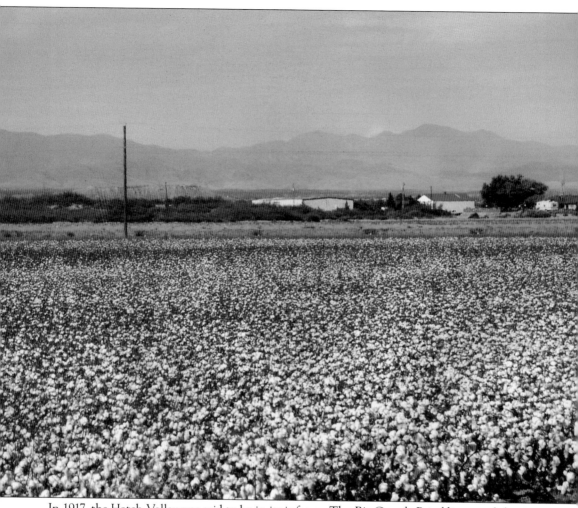

In 1917, the Hatch Valley was said to be in its infancy. The *Rio Grande Republic* quoted the vice president and cashier of the Bank of Hatch in its November 30, 1917, edition as saying, "With the richest land under the sun, plenty of water, and continuous sunshine, we cannot fail to obtain success." The September 27, 1923, edition of the *Rio Grande Farmer* reported that the people of Hatch were elated over cotton prospects, as "cotton is maturing rapidly in the Hatch and Rincon valleys and growers are very optimistic over the outlook. We are all hoping that this week's high prices will continue in effect . . . Already farmers are planning on planting a large acreage in cotton for next year. This year has proved to everyone's satisfaction that our valley can produce excellent staple and large yields at reasonable costs." Cotton continues to be grown in the Hatch Valley today, as shown above. (Courtesy of Joe and Rosie Lack.)

These photographs show a red chile dehydrator plant in operation in Salem, New Mexico. In 2005, the Hatch Valley had ten red chile dehydrators, two frozen green chile–manufacturing plants, three chile sales and marketing companies, three spice companies, and several chile retail stores. According to New Mexico State University, the state of New Mexico is the leading state in chile acreage. Red chile and paprika, a type of red chile when there is low or no heat, represent approximately 40 percent of New Mexico's overall production. It is said that the majority of the state's red chile and paprika crop is dehydrated and crushed into flakes or powders. Is it any really wonder that the Hatch Valley is commonly referred to as the Chile Capital of the World? (Both, courtesy of Sherry Russell.)

The *Las Cruces Sun News* wrote on October 9, 1956, that "Roy E. Harper, of the New Mexico A&M Horticulture Department said today that Dona Ana County ranks first in the nation in the production of improved pecans with an average production of two to three and one-half million pounds annually during the past five years . . . Harper said he believed that this area has certain advantages in pecan production not fully duplicated elsewhere." Harper went on to say, "A factor of disadvantage in growing pecans is our relatively short growing season compared to that of other southern states. We average 200 to 210 days of growing season in the Mesilla and Hatch valleys." Today, more and more pecan trees are being seen in the Hatch Valley. The United States produces 80–95 percent of the world's pecan crops. The photograph above shows a tree shaker used to knock the pecans out of the trees. (Courtesy of Joe and Rosie Lack.)

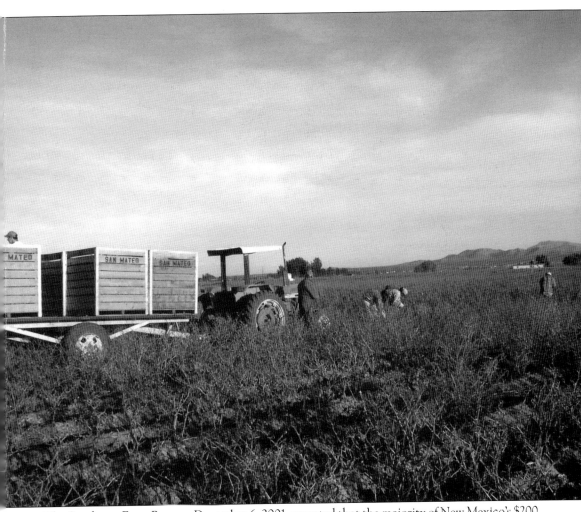

The *Southwest Farm Press* on December 6, 2001, reported that the majority of New Mexico's $200 million chile crop "was laboriously handpicked, just as it had been for the last century." Chile is harvested either green or red (green chile is left to turn to a mature red). The Hatch Valley Chile Festival is celebrated annually in the village of Hatch. In 2011, the New Mexico Chile Advertising Act went into effect, making it illegal to advertise chile as being New Mexico chile unless it had been grown in New Mexico. The law did not address vendors selling chile as Hatch chile when the product had not been specifically grown in the Hatch Valley. This was unfortunate, as there is a distinct flavor associated with Hatch Valley chile that is unique only to this valley. Vendors selling chile in the late summer and early fall in the Hatch Valley welcome visitors to experience the flavor, the unique culture, and the history of their beloved Hatch Valley. (Courtesy of Joe and Rosie Lack.)

Discover Thousands of Local History Books Featuring Millions of Vintage Images

Arcadia Publishing, the leading local history publisher in the United States, is committed to making history accessible and meaningful through publishing books that celebrate and preserve the heritage of America's people and places.

Find more books like this at
www.arcadiapublishing.com

Search for your hometown history, your old stomping grounds, and even your favorite sports team.

Consistent with our mission to preserve history on a local level, this book was printed in South Carolina on American-made paper and manufactured entirely in the United States. Products carrying the accredited Forest Stewardship Council (FSC) label are printed on 100 percent FSC-certified paper.

MADE IN THE USA